Doodles, Portraits and Sketches!

Fun How to Draw Activity Book

Copyright 2016

All Rights reserved. No part of this book may be reproduced or used in any way or formor by any means whether electronic or mechanical, this means that you cannot recordor photocopy any material ideas or tips that are provided in this book.

THE GOLDEN RULES OF DRAWING

1. THERE ARE MANY RIGHT WAYS TO DRAW. IT'S ALL ABOUT YOUR SKILLS AND YOUR PERCEPTION. HOW YOU SEE AN ARMCHAIR AND DRAW A REPRESENTATION OF IT COULD BE ENTIRELY DIFFERENT FROM HOW OTHERS SEE IT. SO GIVE YOURSELF THE TIME AND THE OPPORTUNITY TO EXPLORE YOUR PERSONAL DRAWING STYLE.

2. COMPARE YOUR ARTWORK WITH YOUR OWN. MARVEL AT HOW FAR YOU'VE COME FROM THE RST DAY YOU STARTED DRAWING. GIVE YOURSELF A PAT IN THE BACK!

3. YOU CAN'T MESS UP A DRAWING. SURE, WE'LL GIVE YOU AN IMAGE TO COPY BUT THAT DOESN'T MEAN A WRONG LINE WILL MESS IT ALL UP. SEE PAST THE ERRORS AND INSTEAD, FOCUS ON OPPORTUNITIES TO CREATE. YOUR PENCIL AND CREATIVITY WILL GUIDE YOU NATURALLY.

4. HAVE FUN! DRAWING IS NOT A CONTEST. YOU DON'T HAVE TO COMPARE ART ALL THE TIME.

SOME ARTISTS MAY LIKE TO TRACE WHILE OTHERS FEEL MORE CON DENT CREATING AND CONNECTING SHAPES TO FORM A PICTURE. SHOW US YOUR PERSONAL DRAWING STYLE!

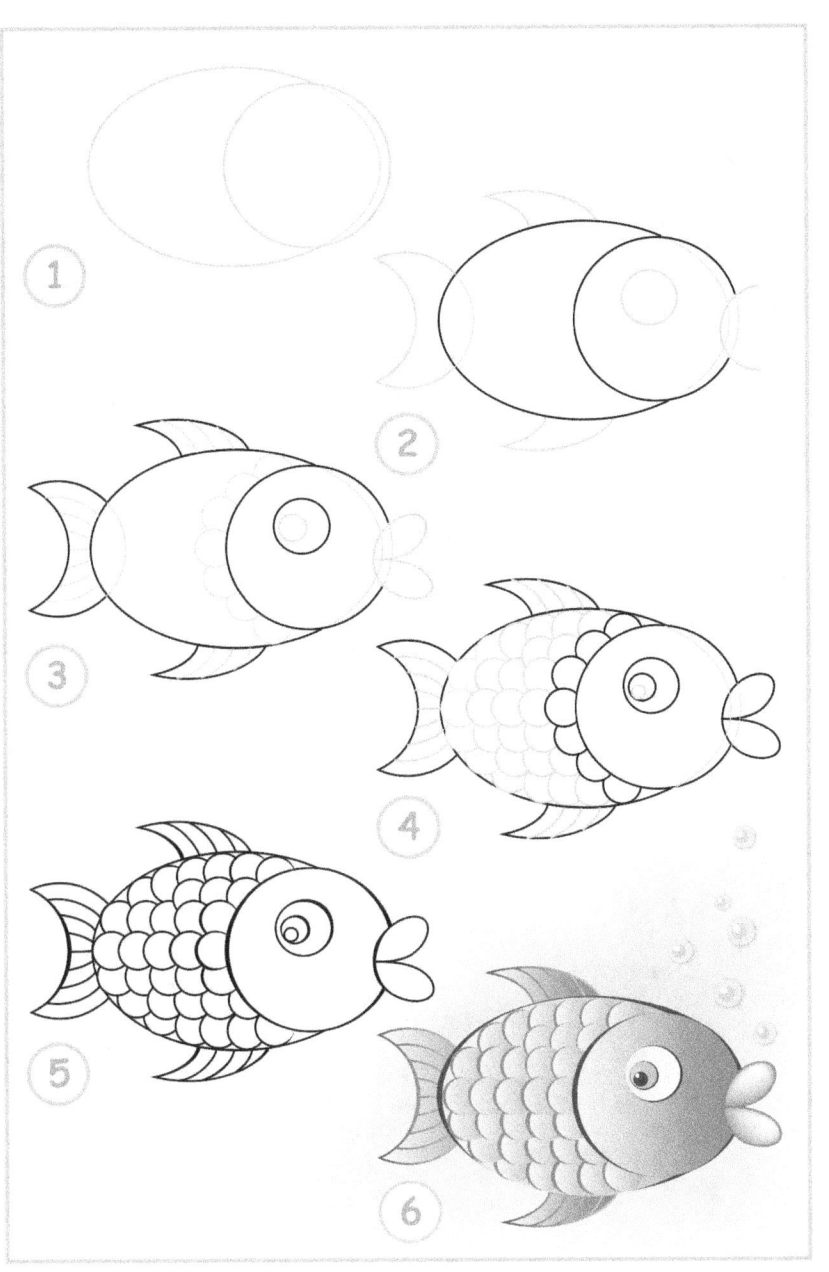

This is your practice drawing space. Draw the images from the previous page here!
Find Other Great Titles By searching for BoBo's Children Activity Books on Your Favorite Book Retailer
Amazon.Com | Barnes & Noble (BN.Com) | Books A Million (BAM.Com)

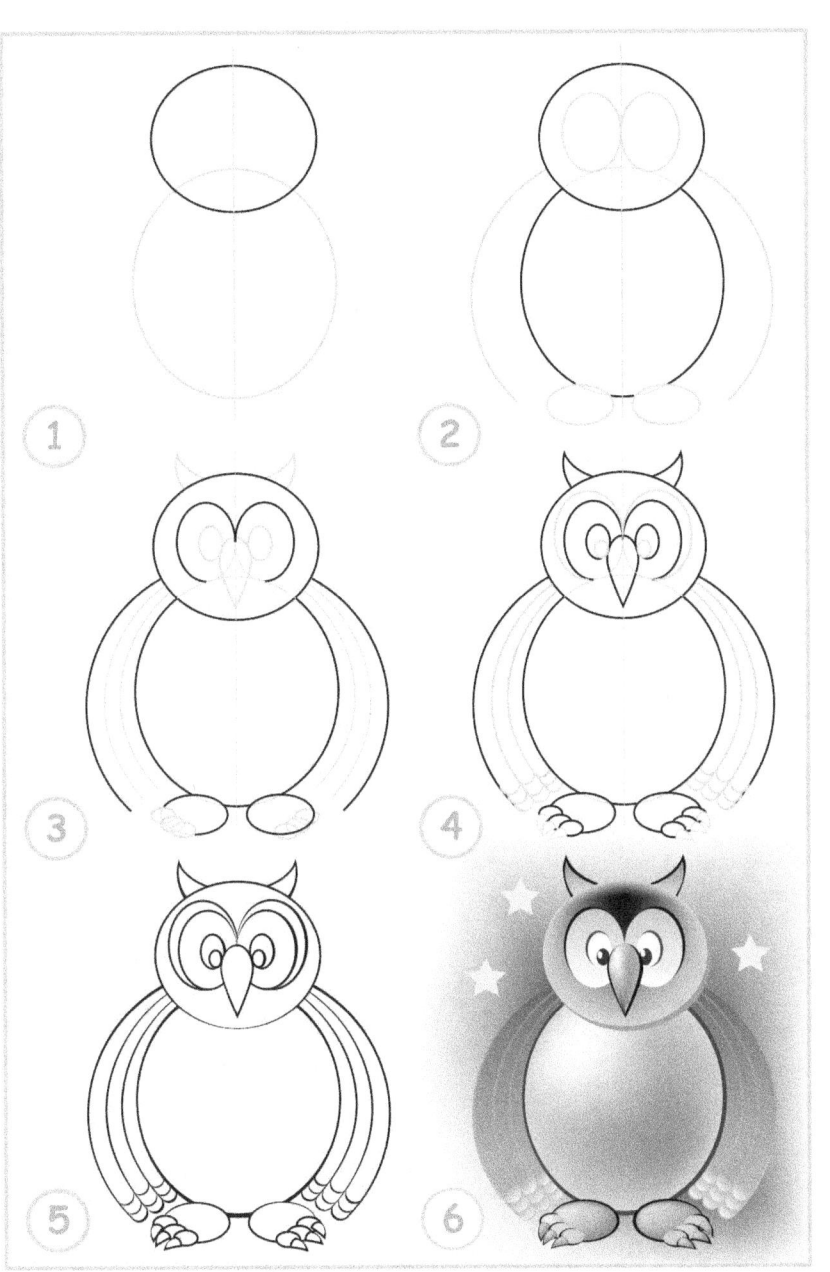

This is your practice drawing space. Draw the images from the previous page here!
Find Other Great Titles By searching for BoBo's Children Activity Books on Your Favorite Book Retailer
Amazon.Com | Barnes & Noble (BN.Com) | Books A Million (BAM.Com)

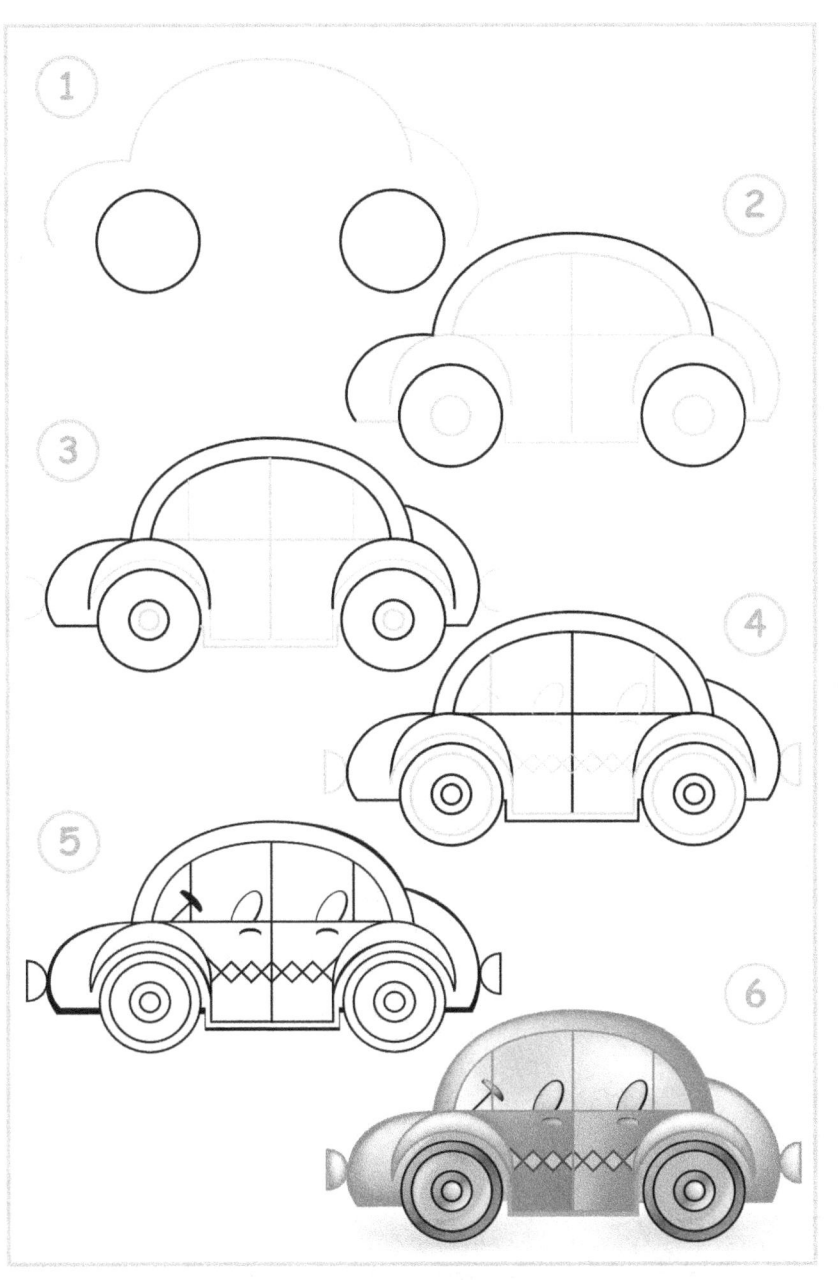

This is your practice drawing space. Draw the images from the previous page here!
Find Other Great Titles By searching for BoBo's Children Activity Books on Your Favorite Book Retailer
Amazon.Com | Barnes & Noble (BN.Com) | Books A Million (BAM.Com)

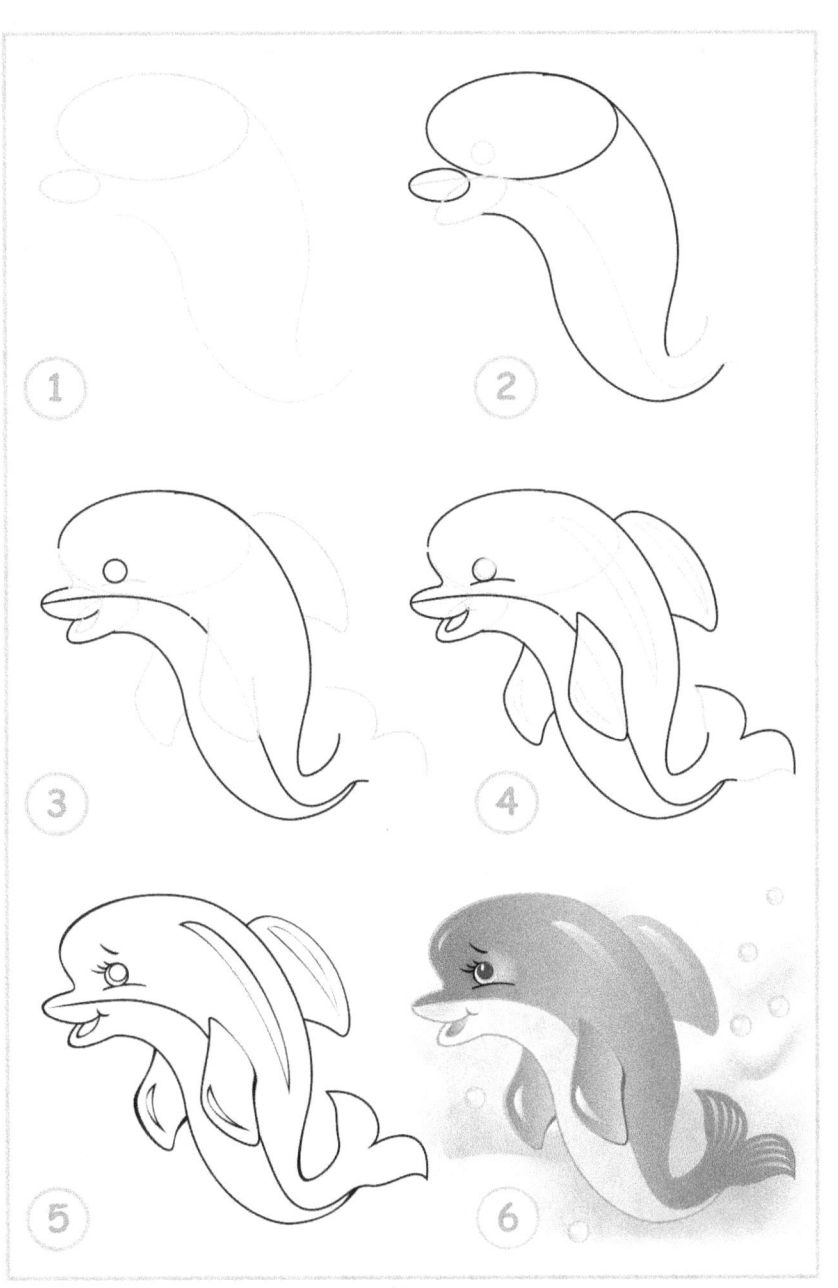

This is your practice drawing space. Draw the images from the previous page here!
Find Other Great Titles By searching for <u>BoBo's Children Activity Books</u> on Your Favorite Book Retailer
Amazon.Com | Barnes & Noble (BN.Com) | Books A Million (BAM.Com)

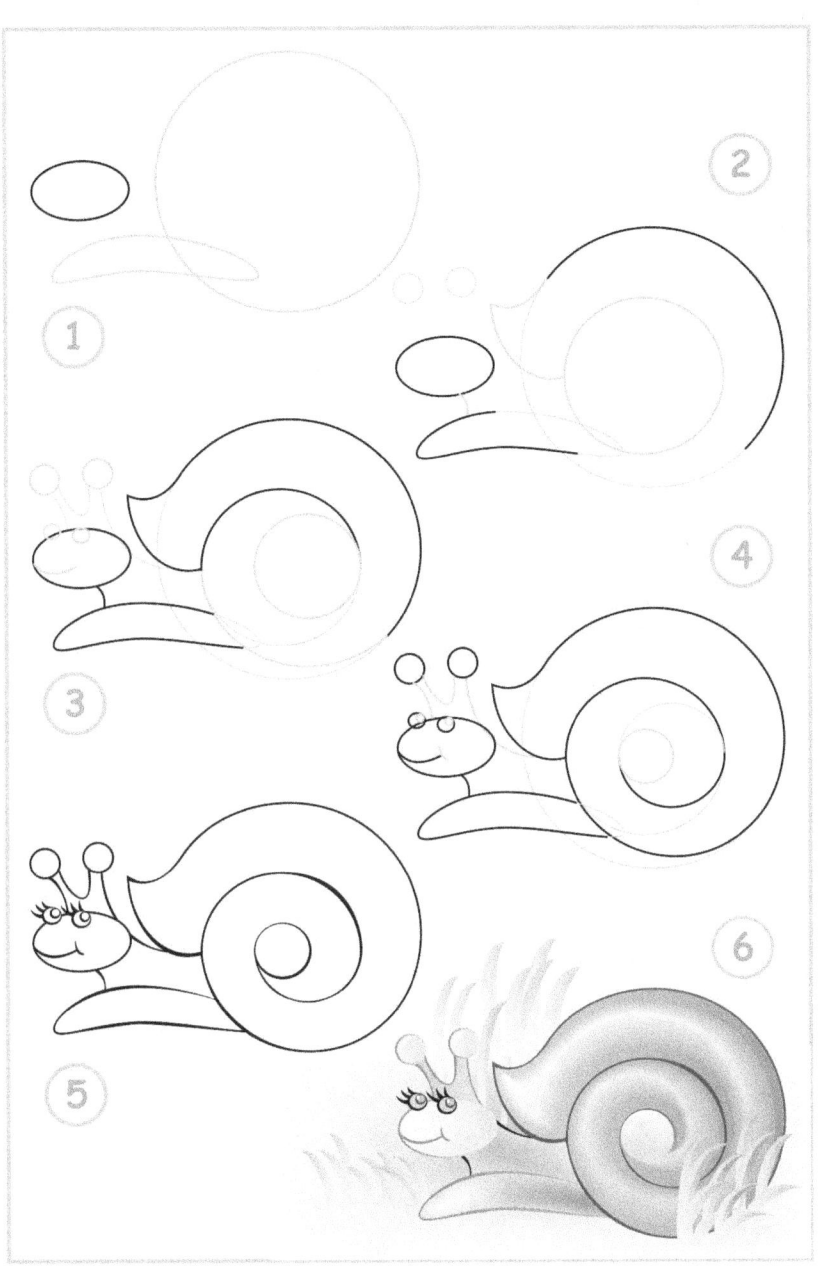

This is your practice drawing space. Draw the images from the previous page here!
Find Other Great Titles By searching for BoBo's Children Activity Books on Your Favorite Book Retailer
Amazon.Com | Barnes & Noble (BN.Com) | Books A Million (BAM.Com)

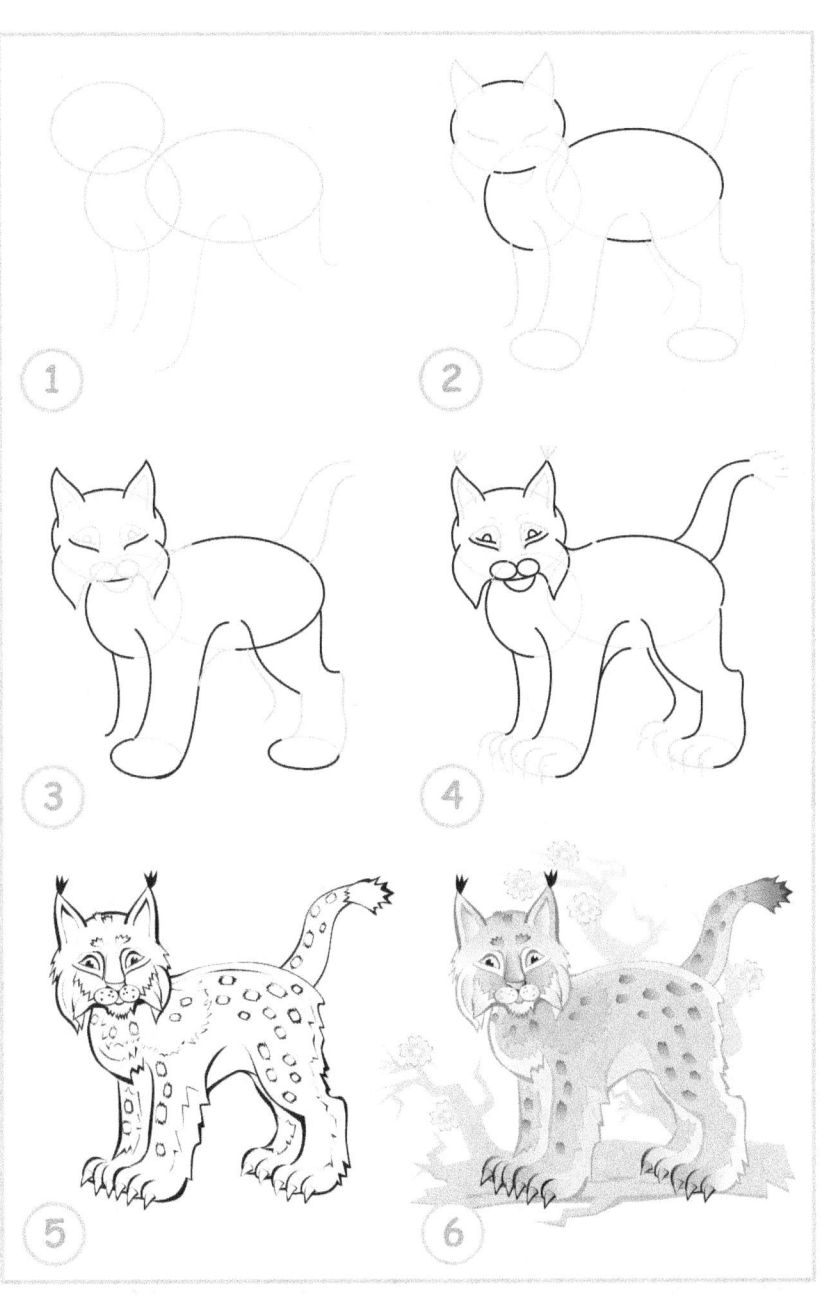

This is your practice drawing space. Draw the images from the previous page here!
Find Other Great Titles By searching for BoBo's Children Activity Books on Your Favorite Book Retailer
Amazon.Com | Barnes & Noble (BN.Com) | Books A Million (BAM.Com)

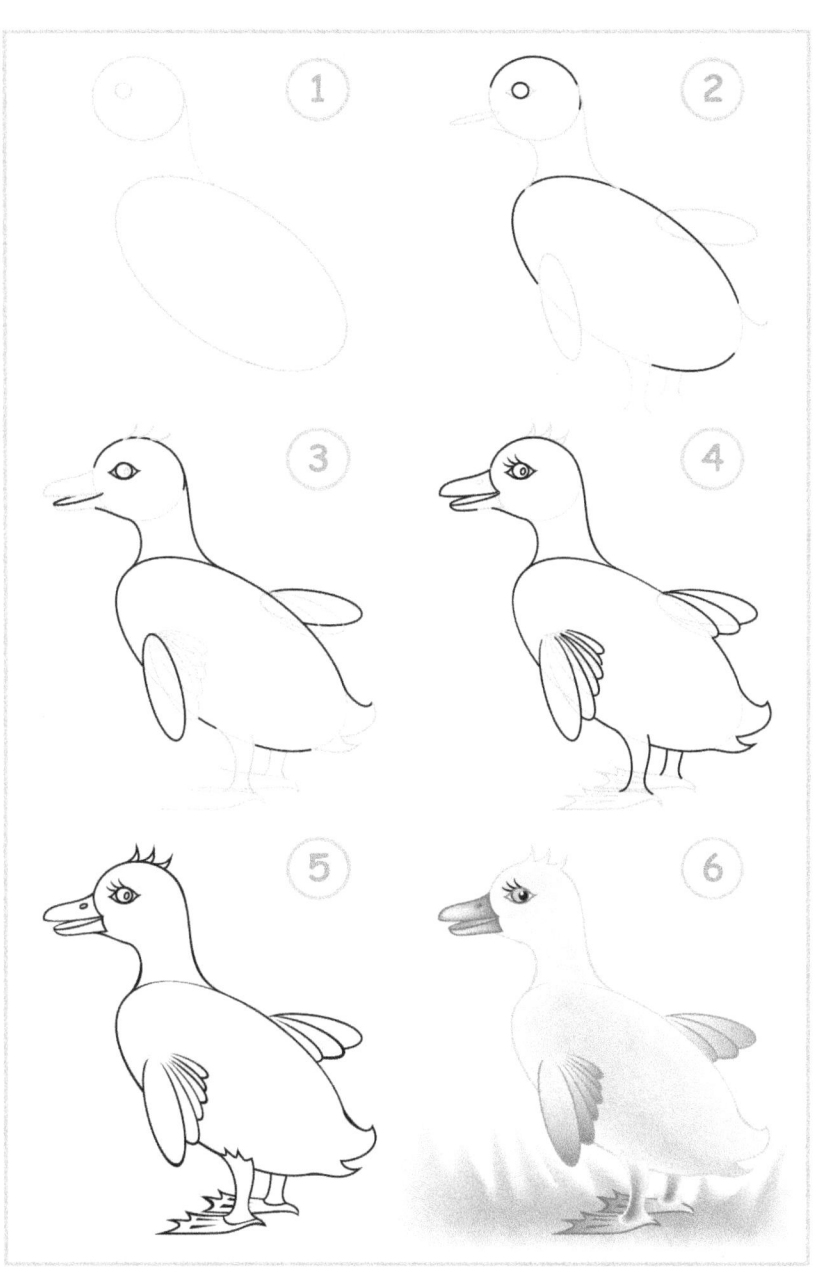

This is your practice drawing space. Draw the images from the previous page here!
Find Other Great Titles By searching for <u>BoBo's Children Activity Books</u> on Your Favorite Book Retailer
Amazon.Com | Barnes & Noble (BN.Com) | Books A Million (BAM.Com)

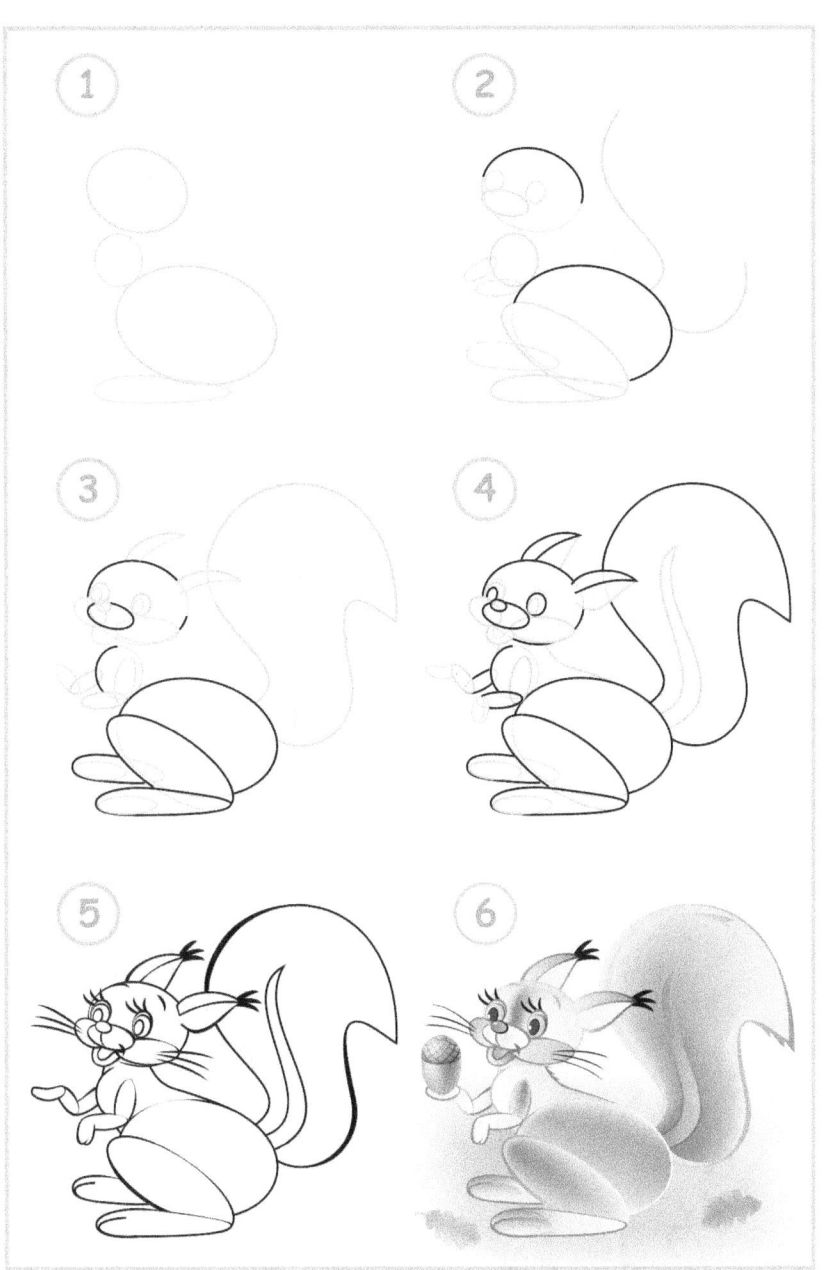

This is your practice drawing space. Draw the images from the previous page here!
Find Other Great Titles By searching for BoBo's Children Activity Books on Your Favorite Book Retailer
Amazon.Com | Barnes & Noble (BN.Com) | Books A Million (BAM.Com)

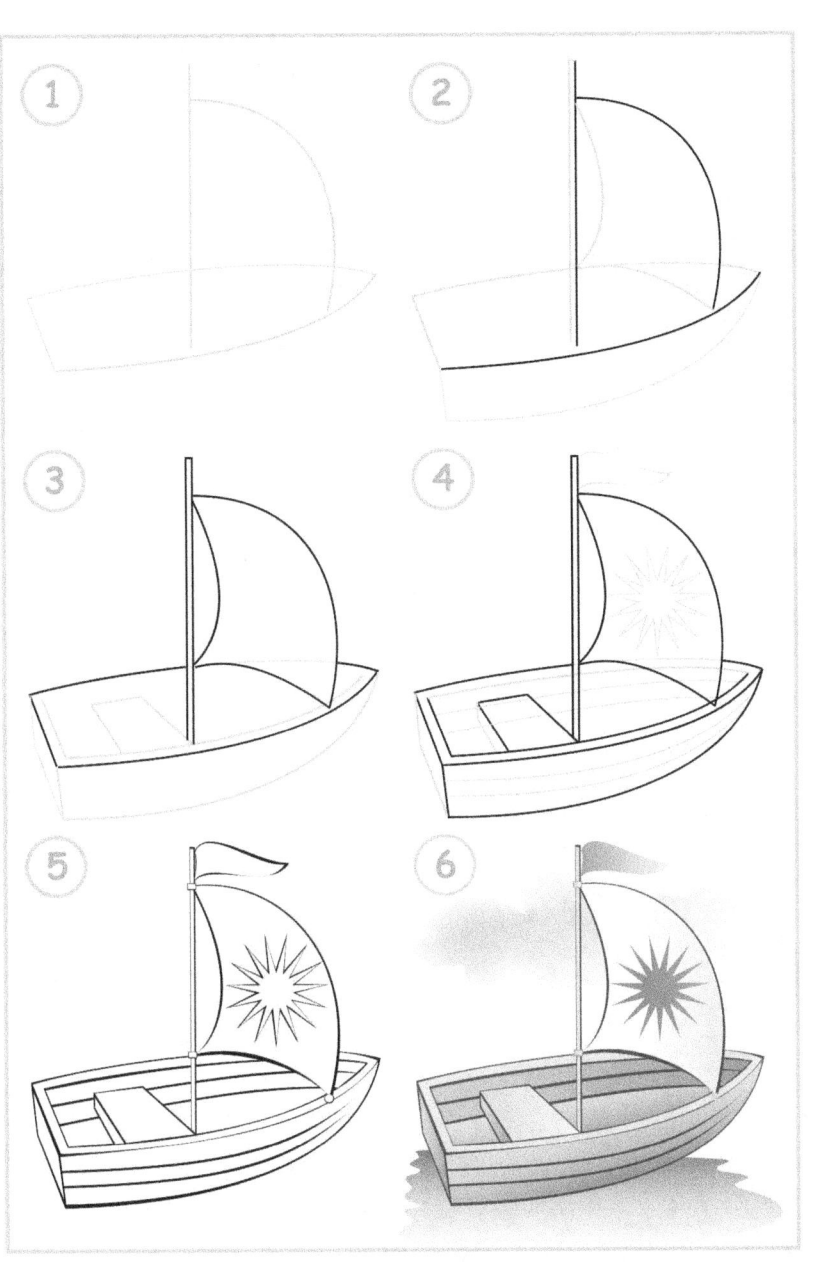

This is your practice drawing space. Draw the images from the previous page here!
Find Other Great Titles By searching for BoBo's Children Activity Books on Your Favorite Book Retailer
Amazon.Com | Barnes & Noble (BN.Com) | Books A Million (BAM.Com)

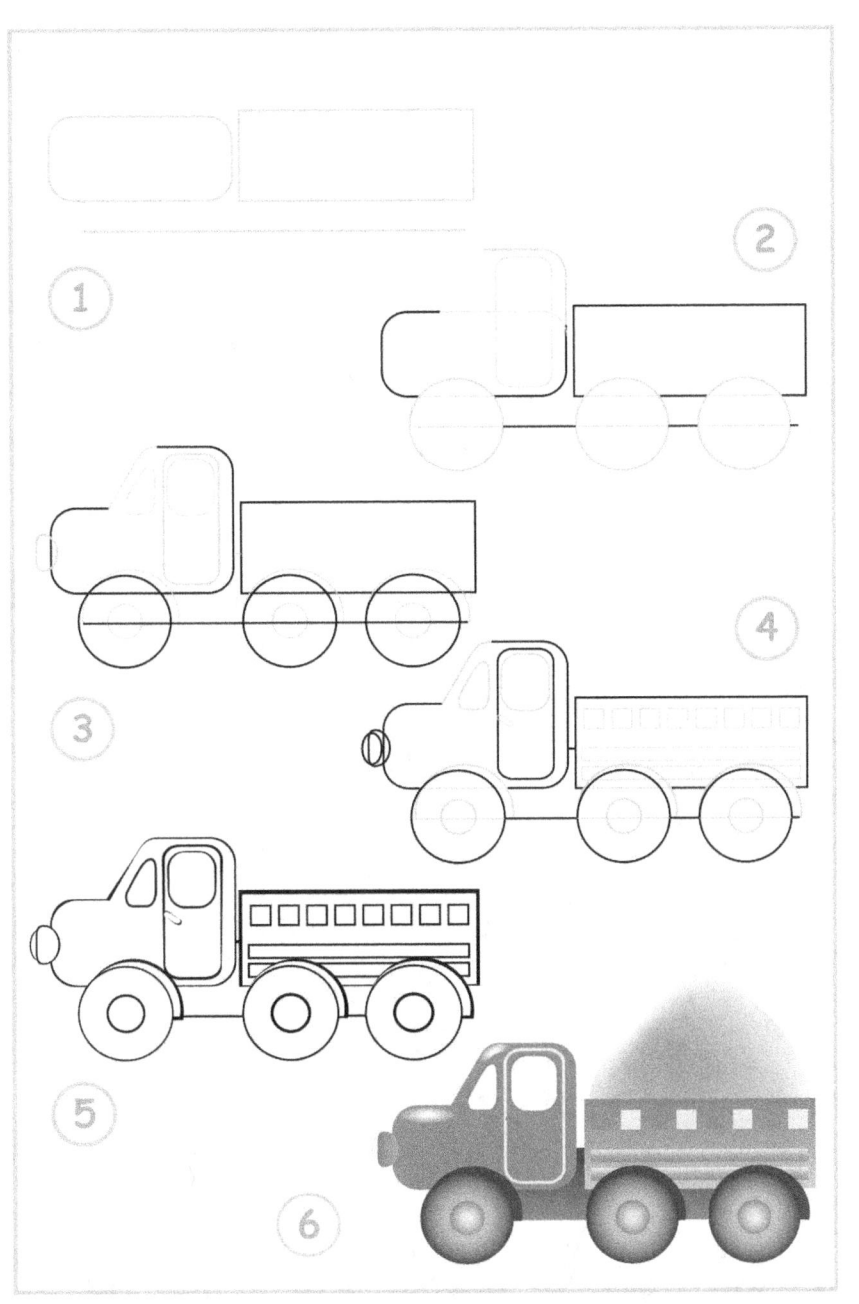

This is your practice drawing space. Draw the images from the previous page here!
Find Other Great Titles By searching for BoBo's Children Activity Books on Your Favorite Book Retailer
Amazon.Com | Barnes & Noble (BN.Com) | Books A Million (BAM.Com)

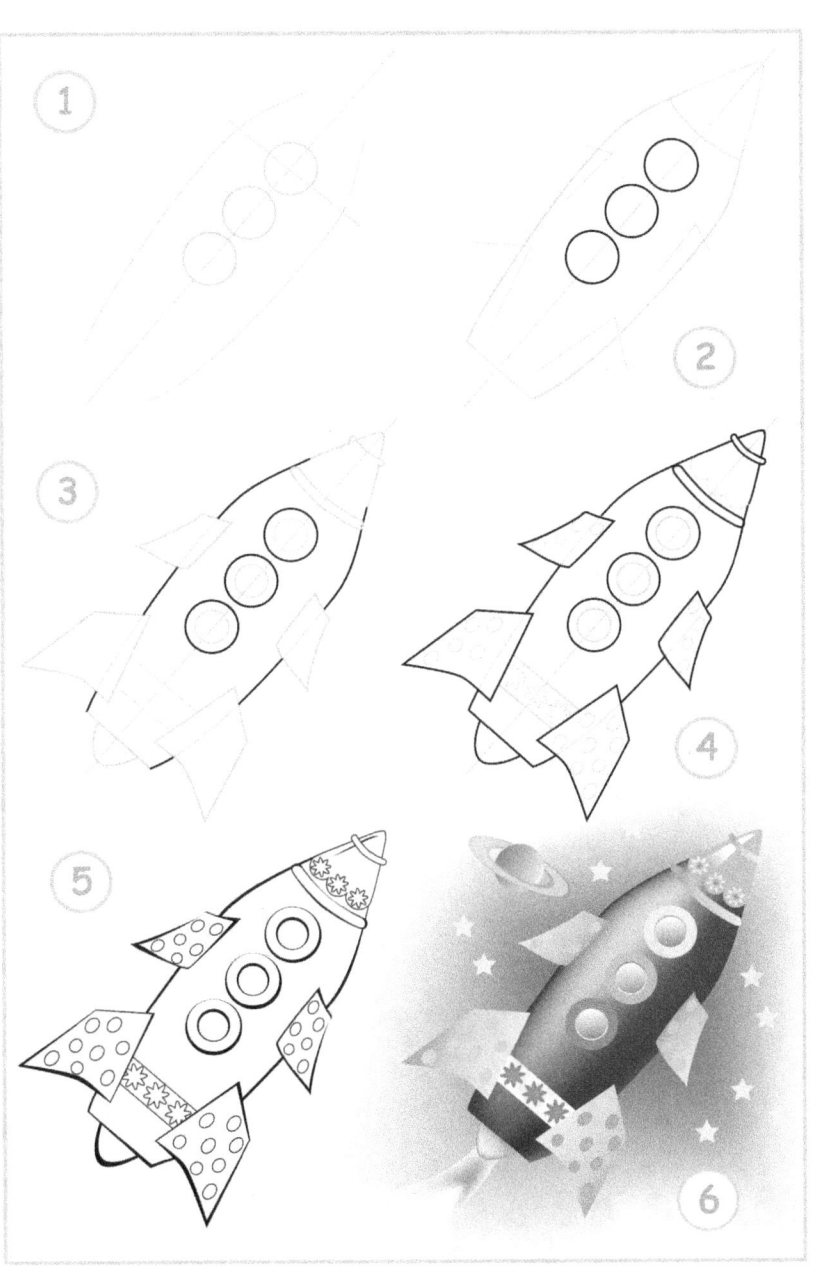

This is your practice drawing space. Draw the images from the previous page here!
Find Other Great Titles By searching for <u>BoBo's Children Activity Books</u> on Your Favorite Book Retailer
Amazon.Com | Barnes & Noble (BN.Com) | Books A Million (BAM.Com)

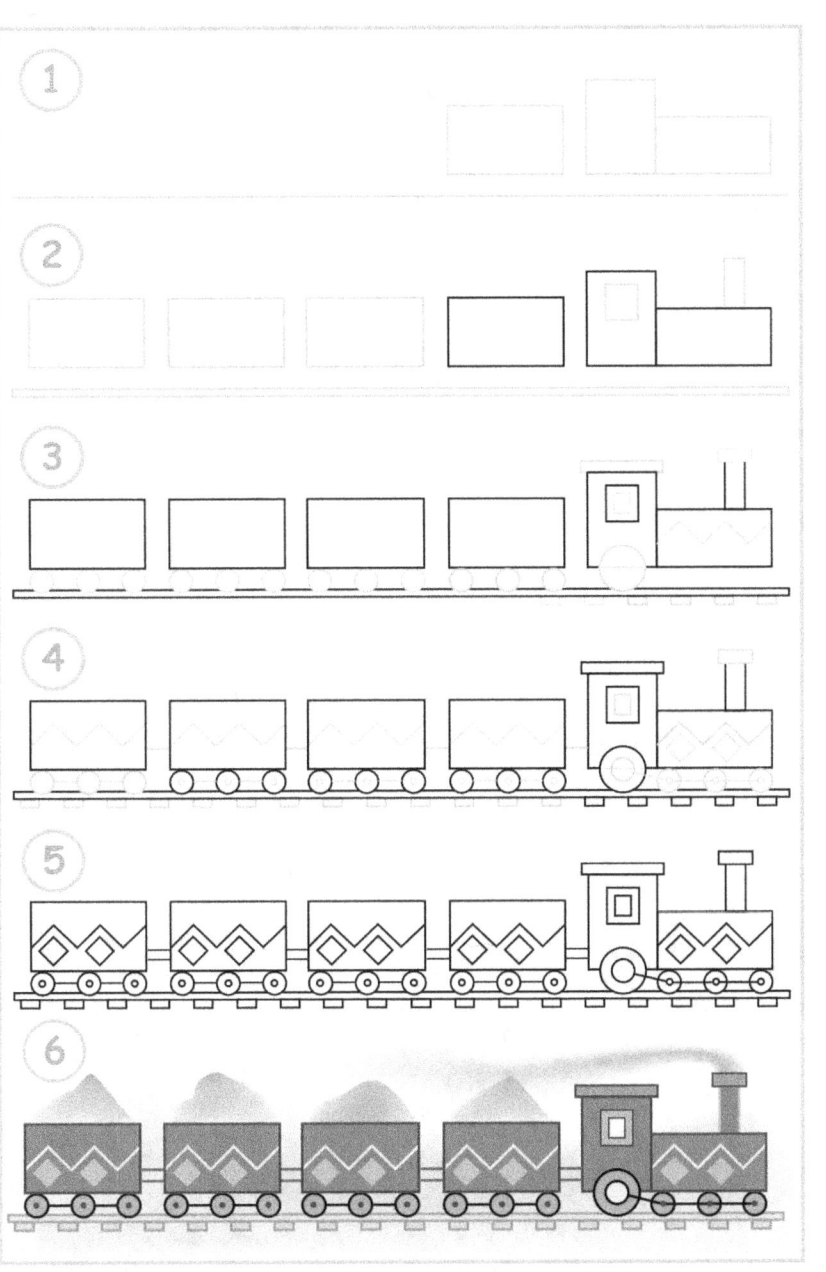

This is your practice drawing space. Draw the images from the previous page here!
Find Other Great Titles By searching for <u>BoBo's Children Activity Books</u> on Your Favorite Book Retailer
Amazon.Com | Barnes & Noble (BN.Com) | Books A Million (BAM.Com)

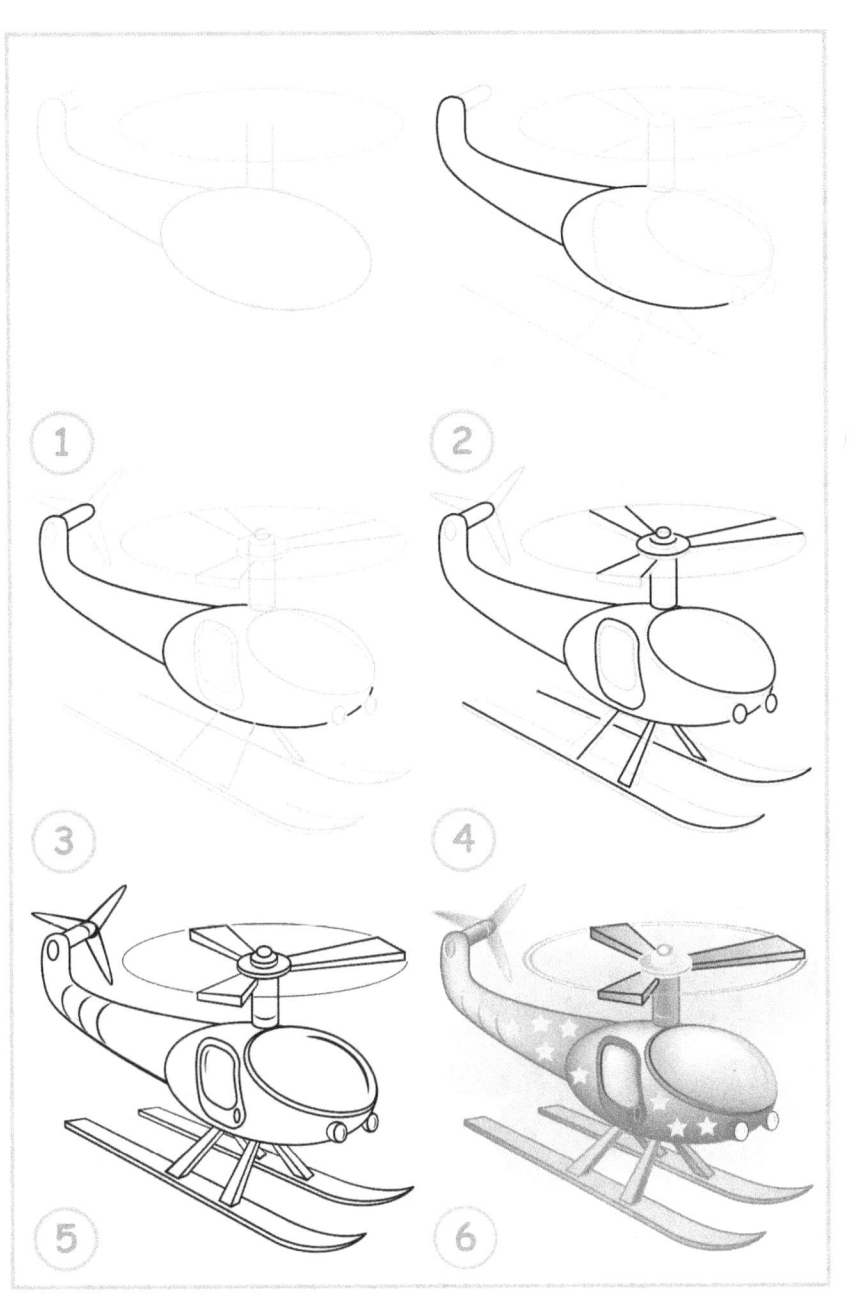

This is your practice drawing space. Draw the images from the previous page here!
Find Other Great Titles By searching for BoBo's Children Activity Books on Your Favorite Book Retailer
Amazon.Com | Barnes & Noble (BN.Com) | Books A Million (BAM.Com)

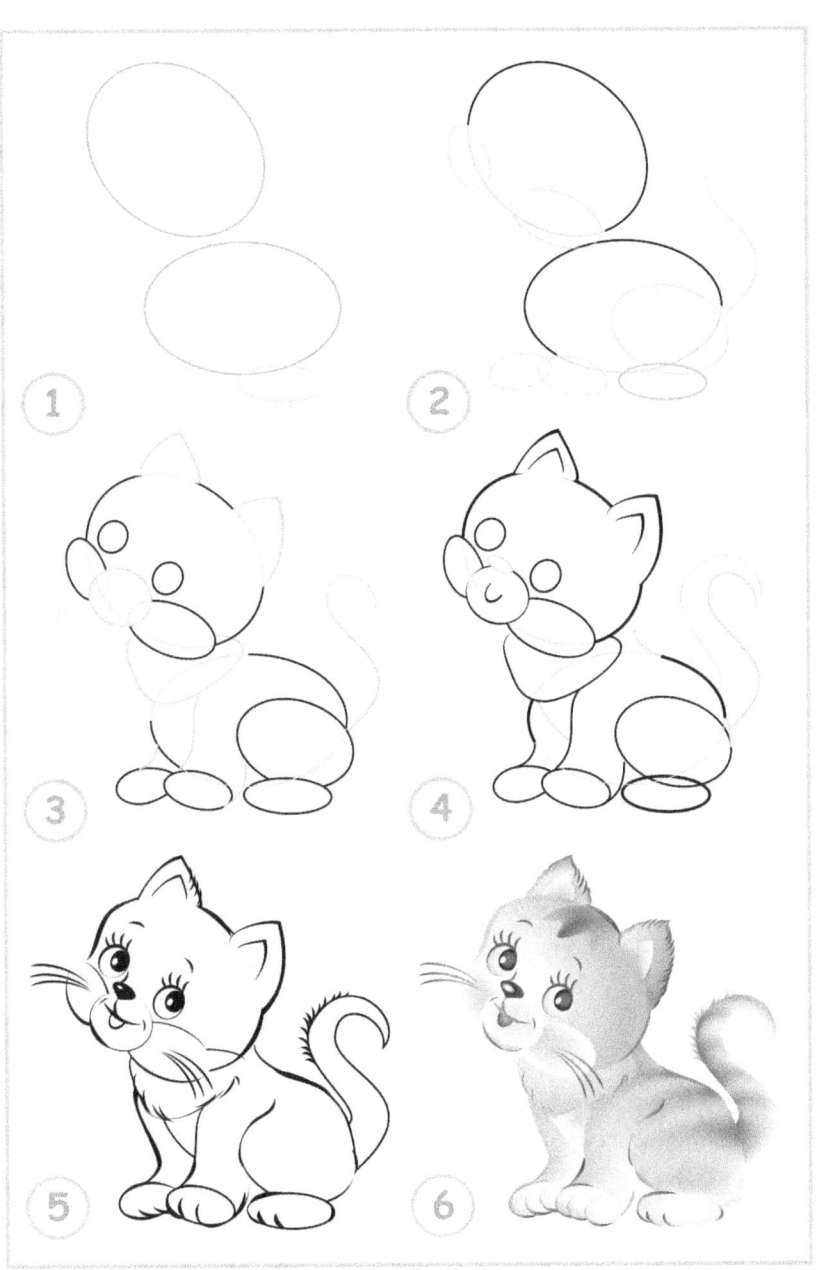

This is your practice drawing space. Draw the images from the previous page here!
Find Other Great Titles By searching for BoBo's Children Activity Books on Your Favorite Book Retailer
Amazon.Com | Barnes & Noble (BN.Com) | Books A Million (BAM.Com)

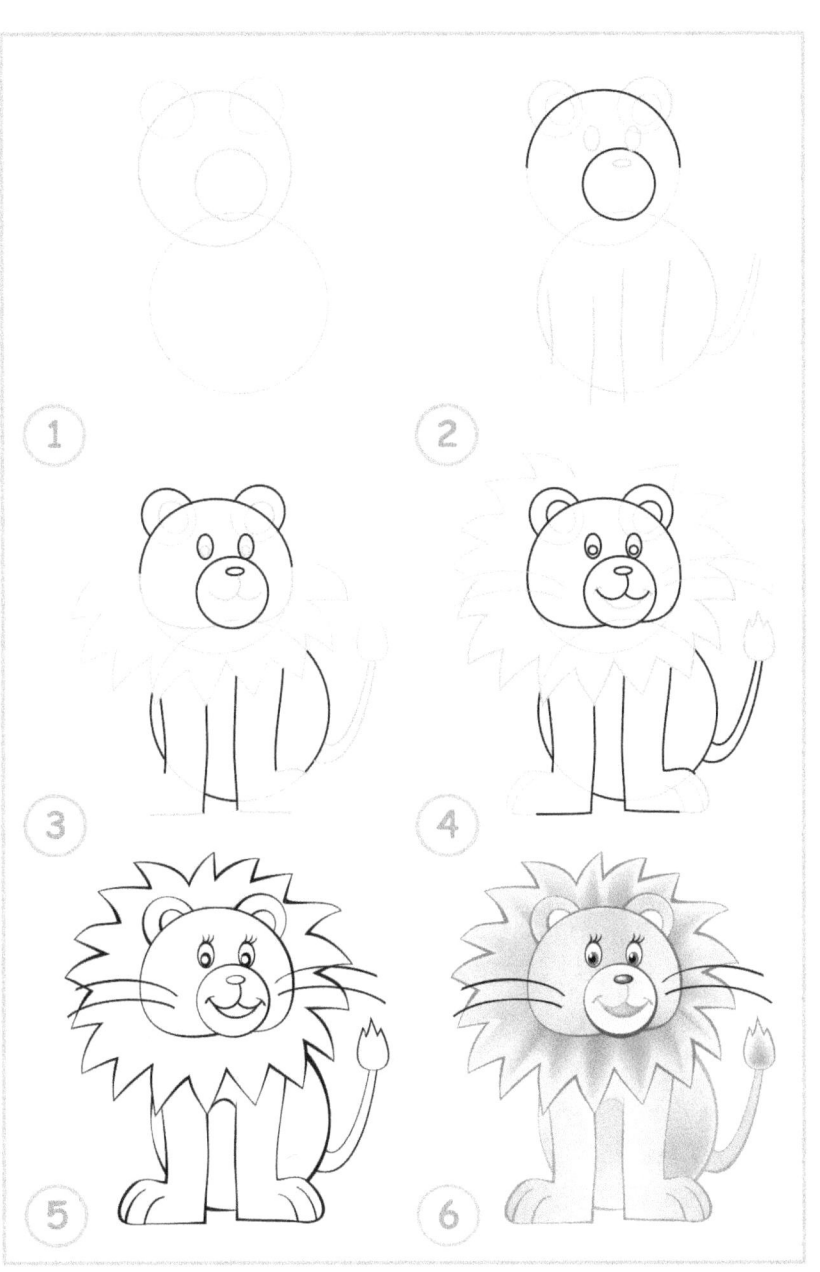

This is your practice drawing space. Draw the images from the previous page here!
Find Other Great Titles By searching for BoBo's Children Activity Books on Your Favorite Book Retailer
Amazon.Com | Barnes & Noble (BN.Com) | Books A Million (BAM.Com)

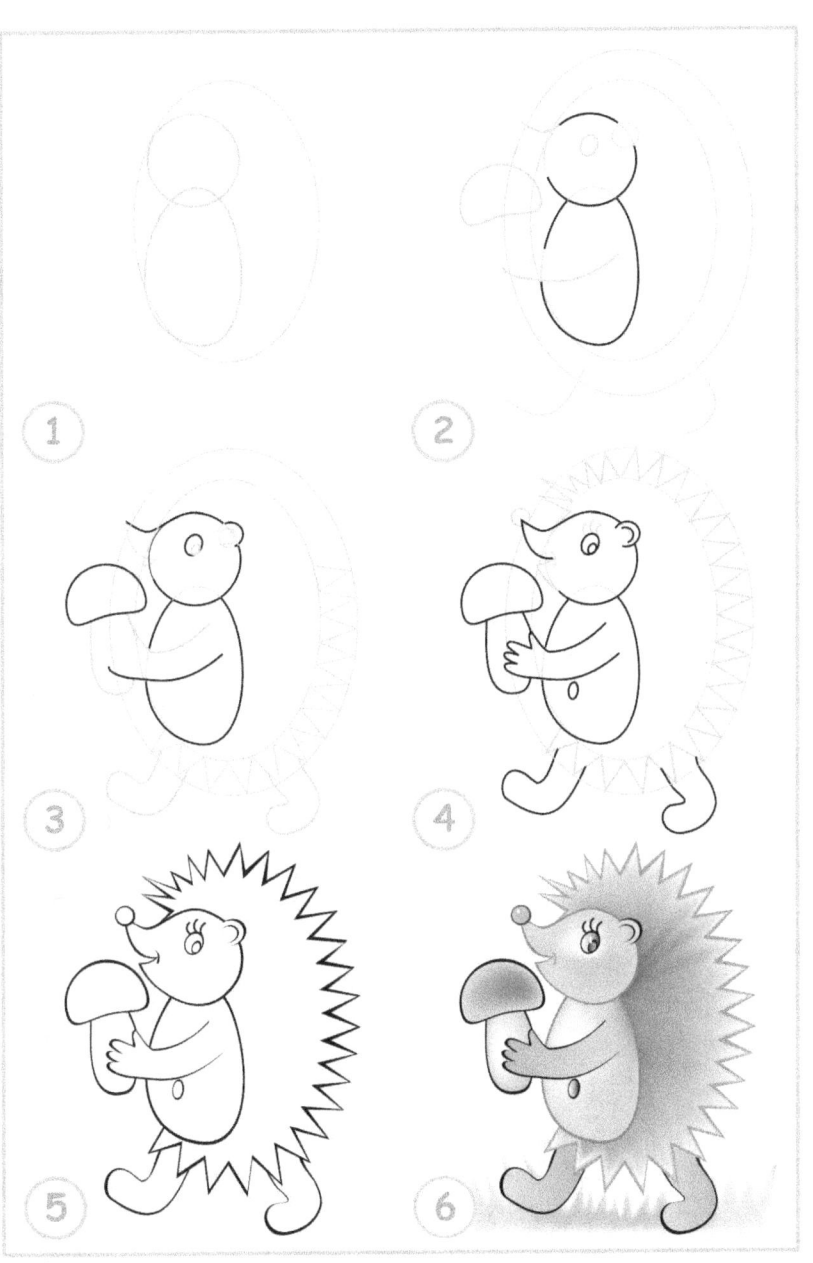

This is your practice drawing space. Draw the images from the previous page here!
Find Other Great Titles By searching for BoBo's Children Activity Books on Your Favorite Book Retailer
Amazon.Com | Barnes & Noble (BN.Com) | Books A Million (BAM.Com)

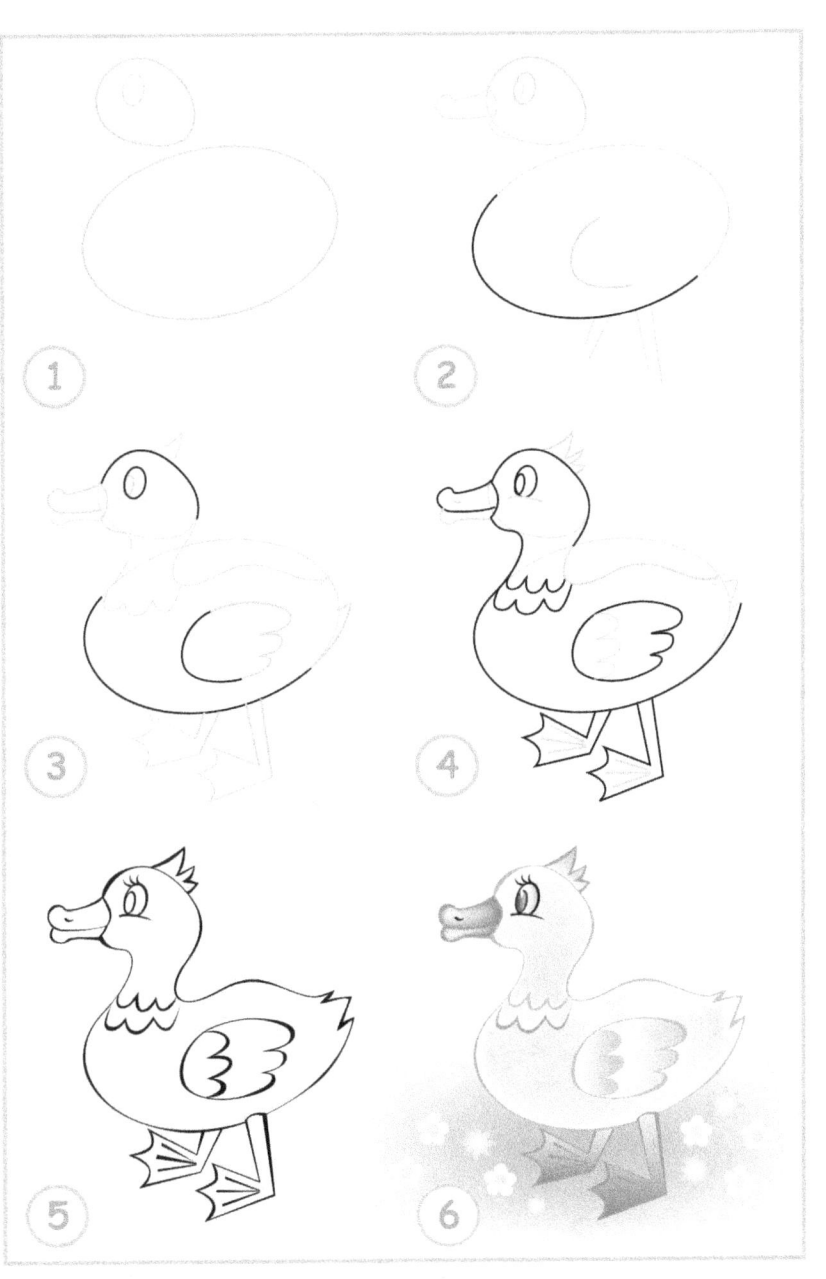

This is your practice drawing space. Draw the images from the previous page here!
Find Other Great Titles By searching for BoBo's Children Activity Books on Your Favorite Book Retailer
Amazon.Com | Barnes & Noble (BN.Com) | Books A Million (BAM.Com)

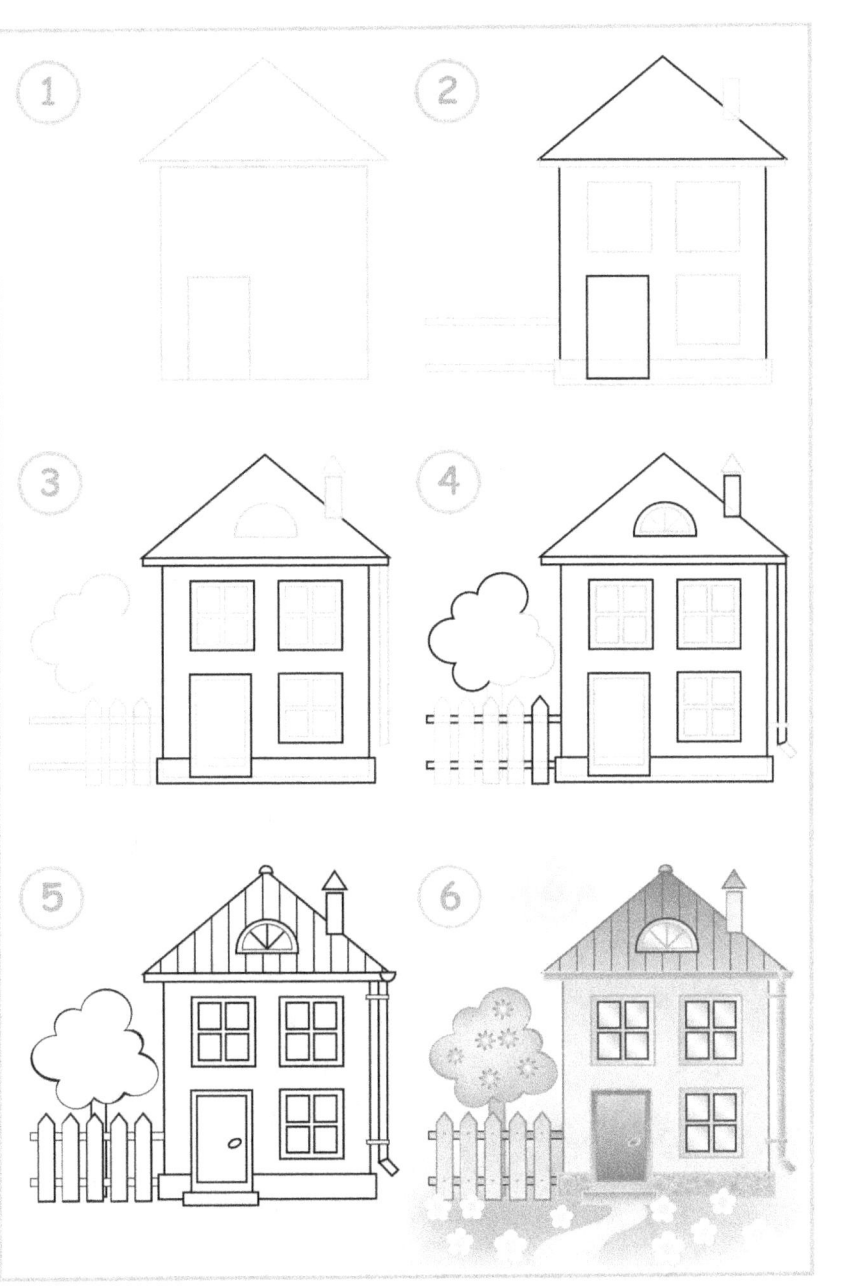

This is your practice drawing space. Draw the images from the previous page here!
Find Other Great Titles By searching for BoBo's Children Activity Books on Your Favorite Book Retailer
Amazon.Com | Barnes & Noble (BN.Com) | Books A Million (BAM.Com)

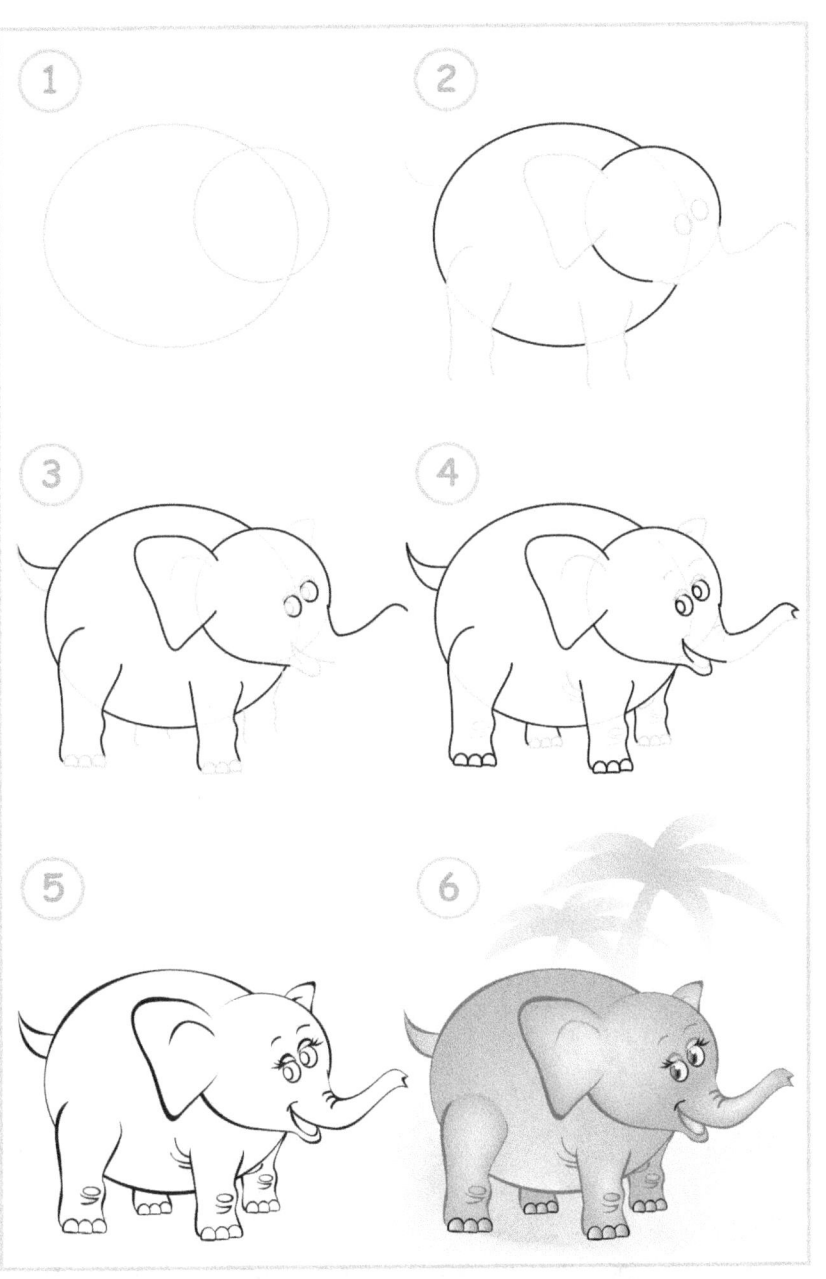

This is your practice drawing space. Draw the images from the previous page here!
Find Other Great Titles By searching for BoBo's Children Activity Books on Your Favorite Book Retailer
Amazon.Com | Barnes & Noble (BN.Com) | Books A Million (BAM.Com)

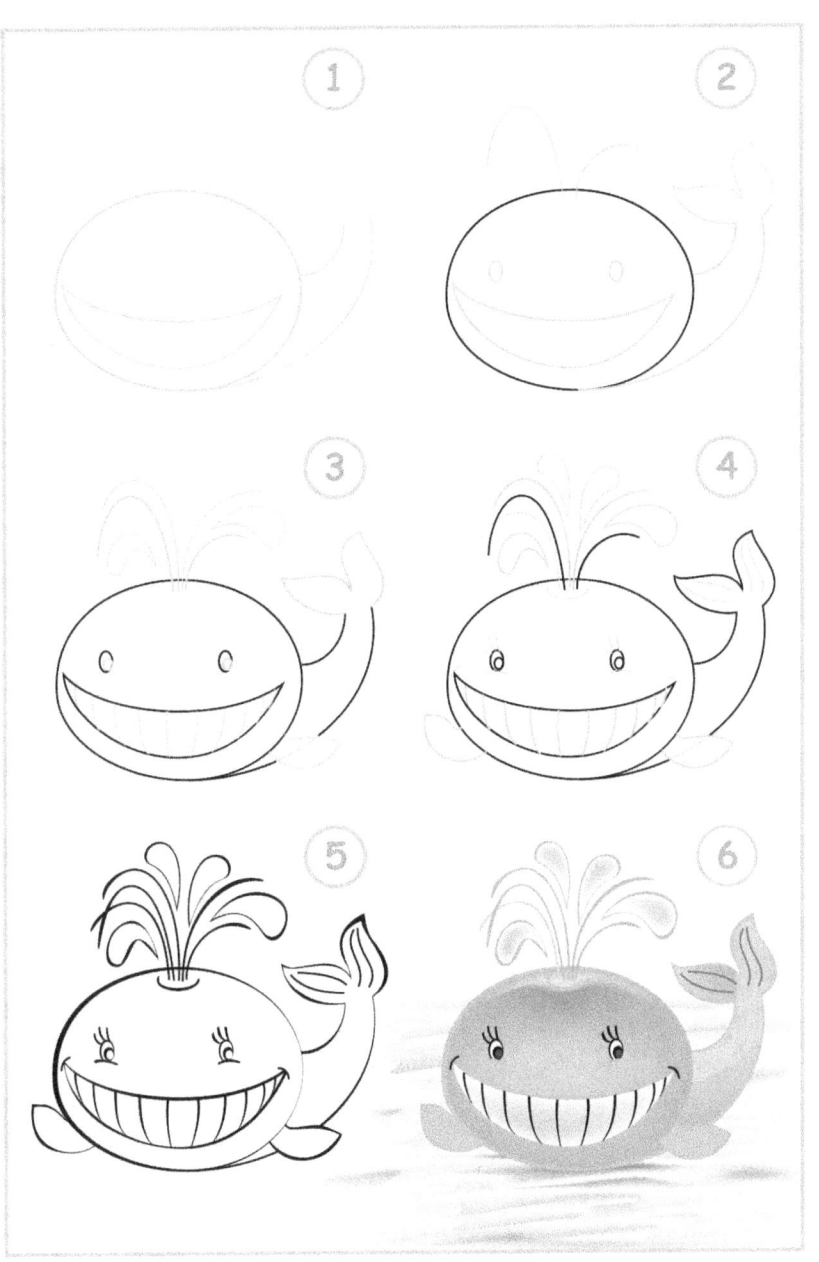

This is your practice drawing space. Draw the images from the previous page here!
Find Other Great Titles By searching for <u>BoBo's Children Activity Books</u> on Your Favorite Book Retailer
Amazon.Com | Barnes & Noble (BN.Com) | Books A Million (BAM.Com)

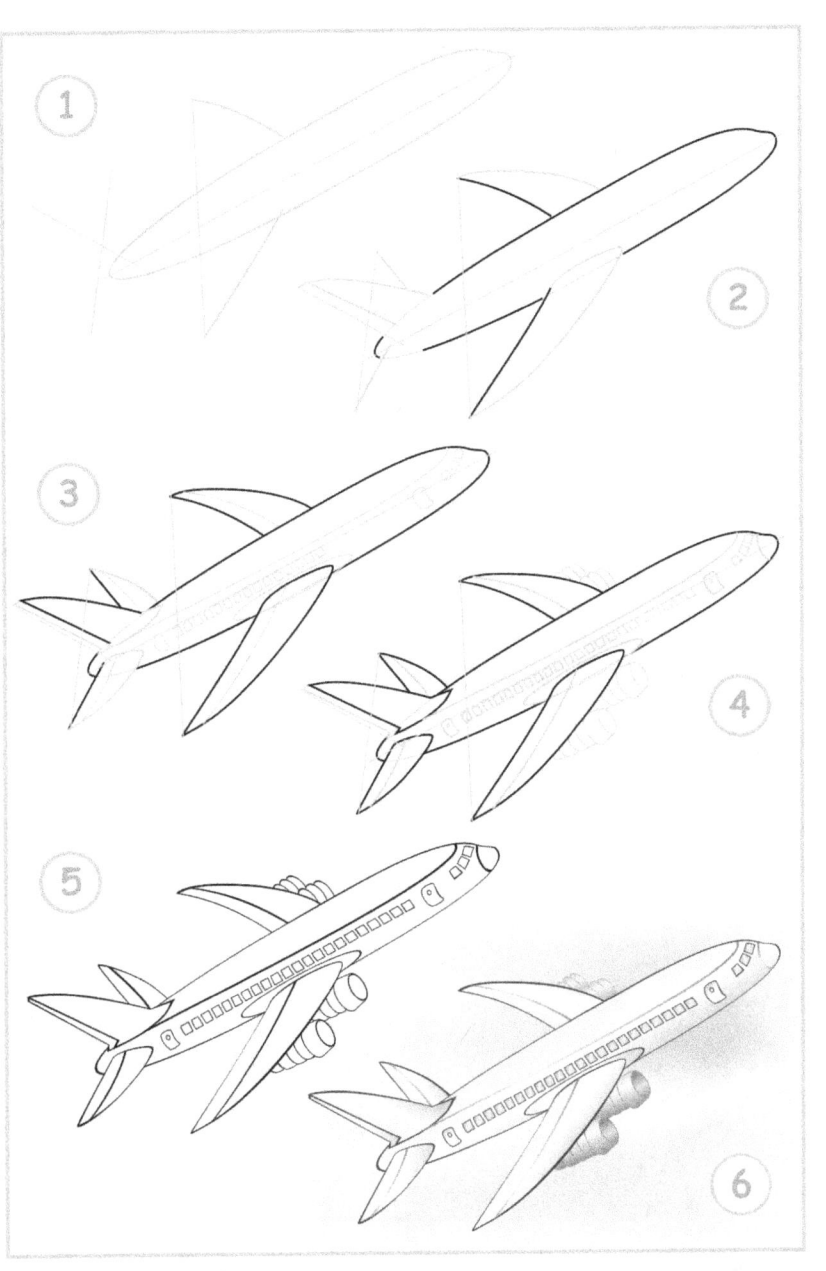

This is your practice drawing space. Draw the images from the previous page here!
Find Other Great Titles By searching for BoBo's Children Activity Books on Your Favorite Book Retailer
Amazon.Com | Barnes & Noble (BN.Com) | Books A Million (BAM.Com)

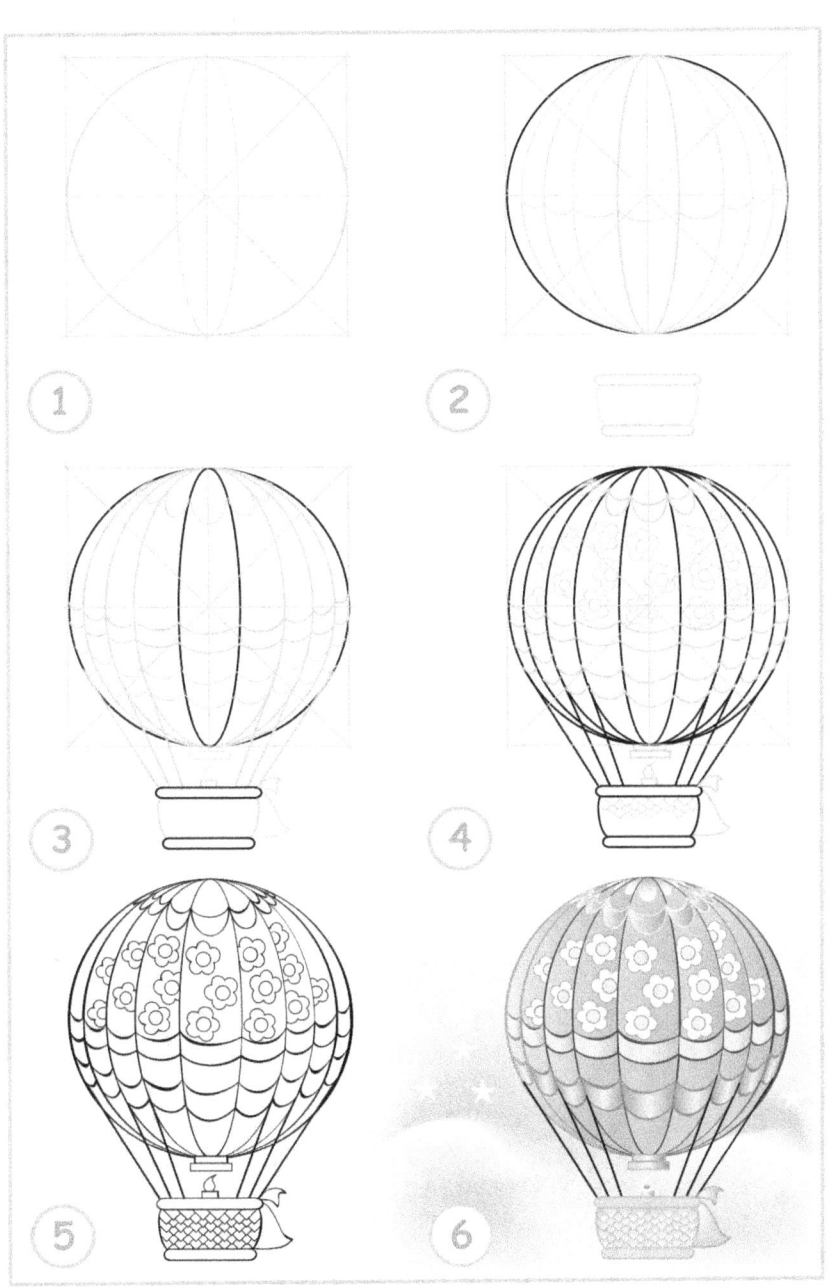

This is your practice drawing space. Draw the images from the previous page here!
Find Other Great Titles By searching for BoBo's Children Activity Books on Your Favorite Book Retailer
Amazon.Com | Barnes & Noble (BN.Com) | Books A Million (BAM.Com)

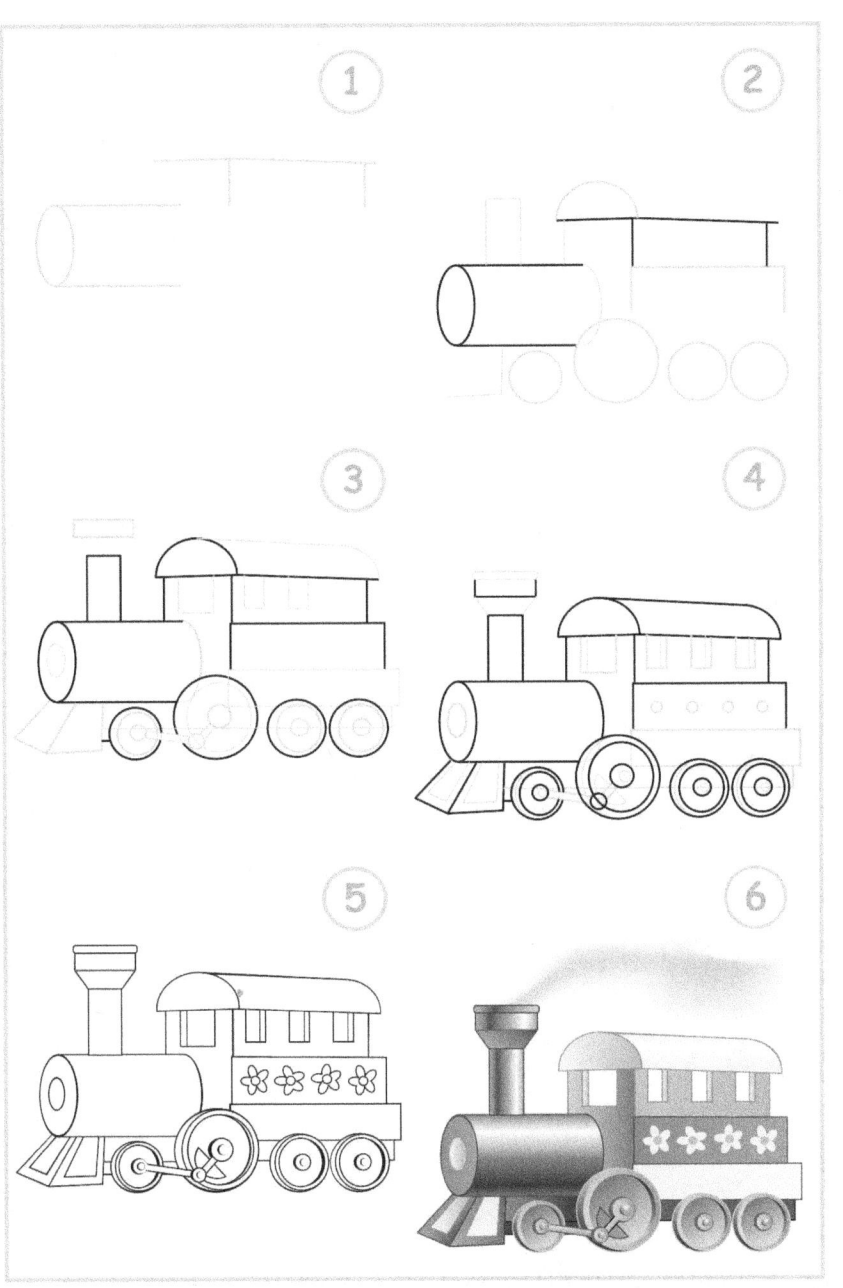

This is your practice drawing space. Draw the images from the previous page here!
Find Other Great Titles By searching for BoBo's Children Activity Books on Your Favorite Book Retailer
Amazon.Com | Barnes & Noble (BN.Com) | Books A Million (BAM.Com)

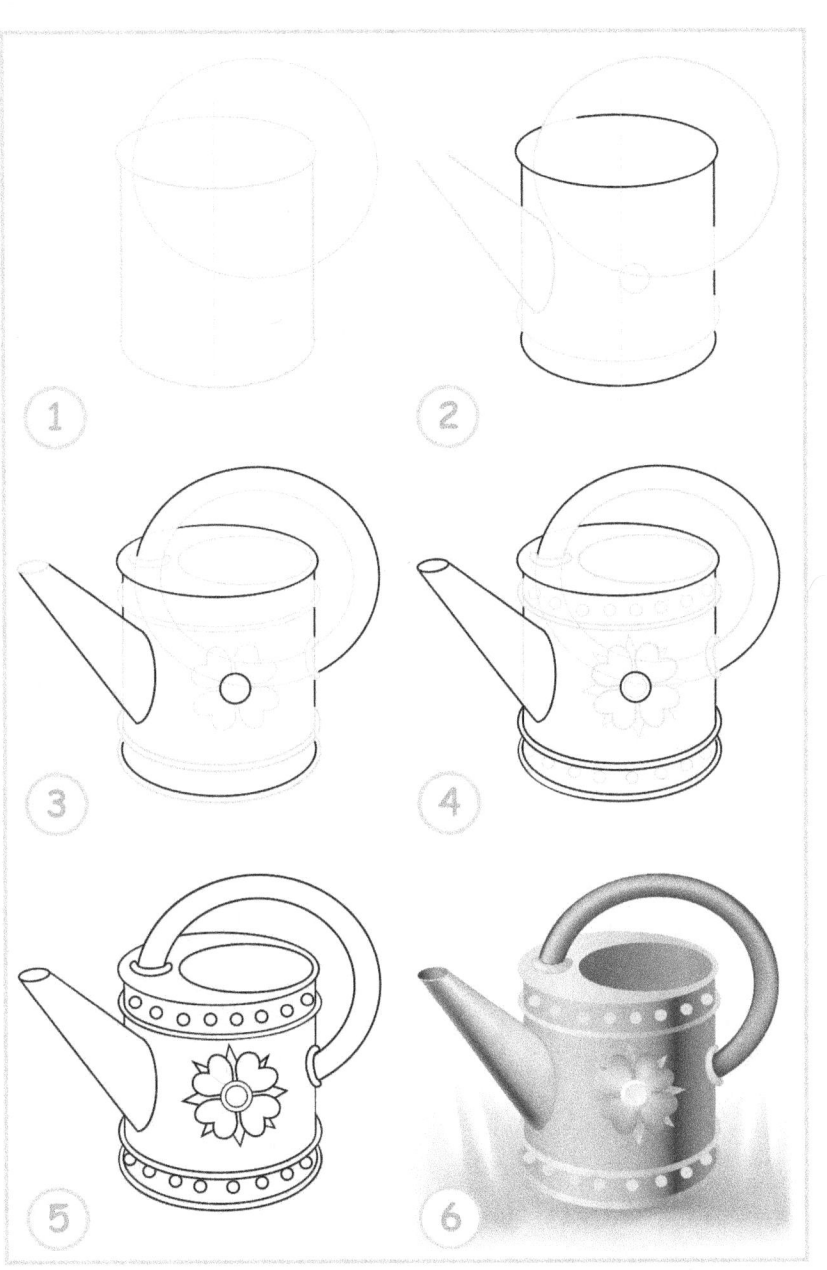

This is your practice drawing space. Draw the images from the previous page here!
Find Other Great Titles By searching for BoBo's Children Activity Books on Your Favorite Book Retailer
Amazon.Com | Barnes & Noble (BN.Com) | Books A Million (BAM.Com)

This is your practice drawing space. Draw the images from the previous page here!
Find Other Great Titles By searching for BoBo's Children Activity Books on Your Favorite Book Retailer
Amazon.Com | Barnes & Noble (BN.Com) | Books A Million (BAM.Com)

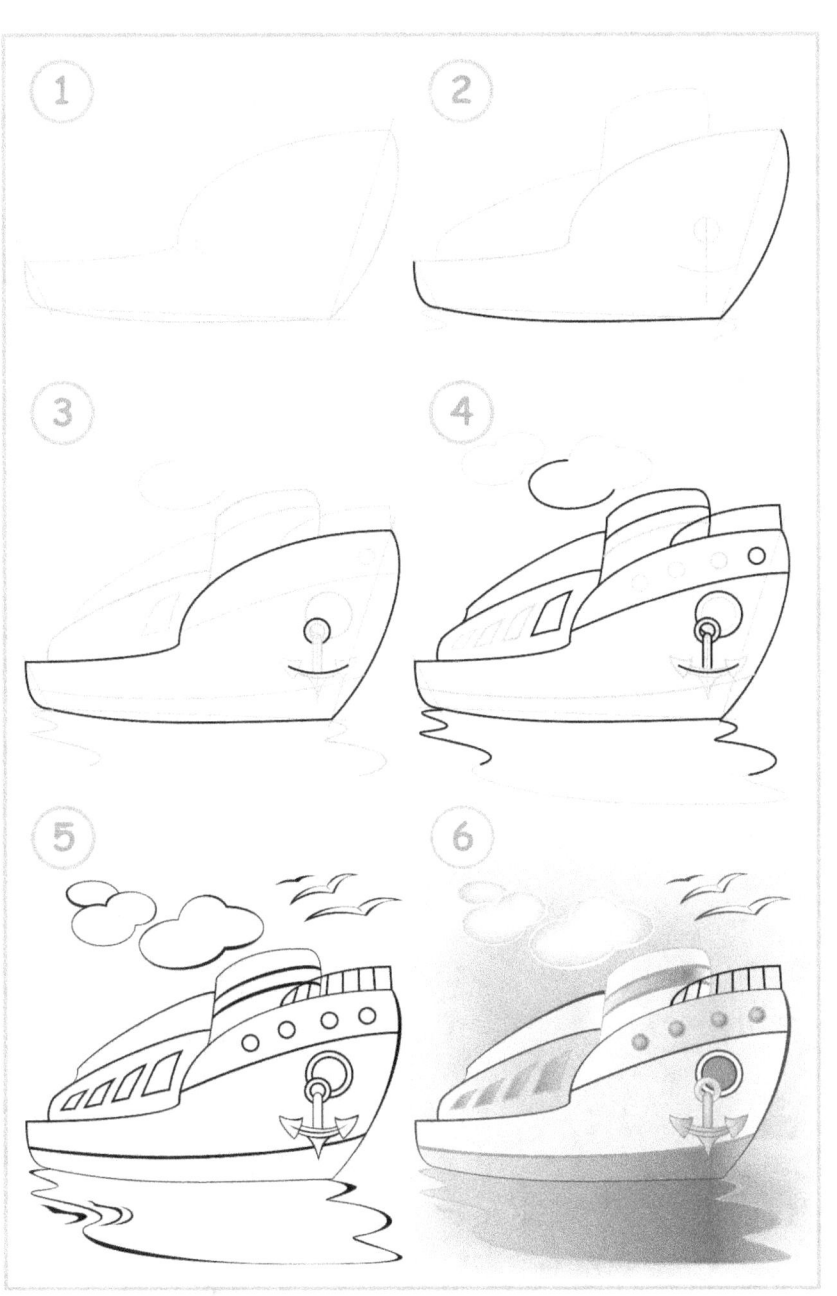

This is your practice drawing space. Draw the images from the previous page here!
Find Other Great Titles By searching for BoBo's Children Activity Books on Your Favorite Book Retailer
Amazon.Com | Barnes & Noble (BN.Com) | Books A Million (BAM.Com)

TRANSFER PARTS OF THE IMAGES FROM THE SMALL GRIDS TO THE BIG GRIDS. GOOD LUCK!

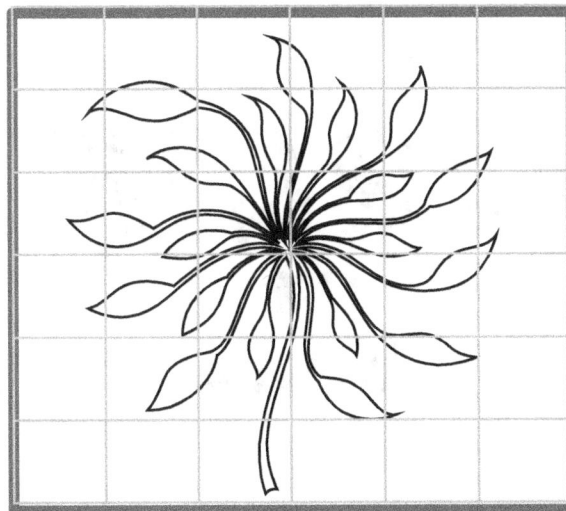

DRAW
THE
IMAGE

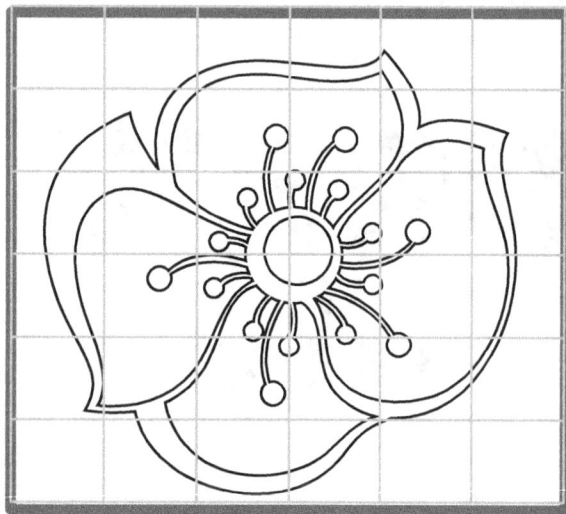

DRAW
THE
IMAGE

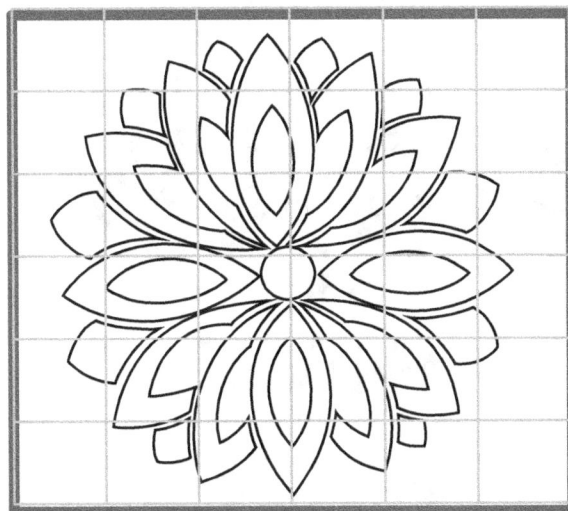

DRAW
THE
IMAGE

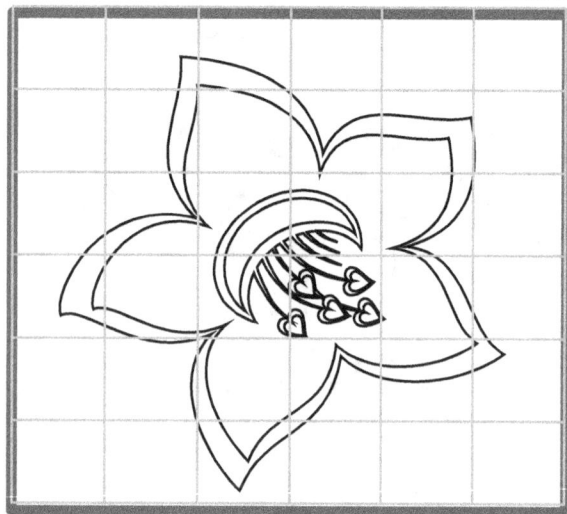

DRAW
THE
IMAGE

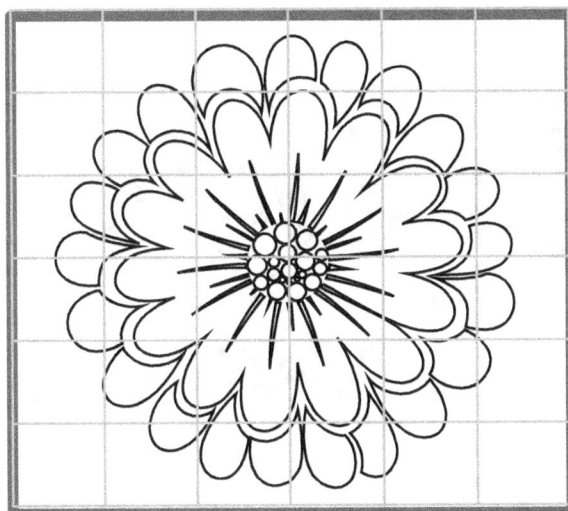

DRAW
THE
IMAGE

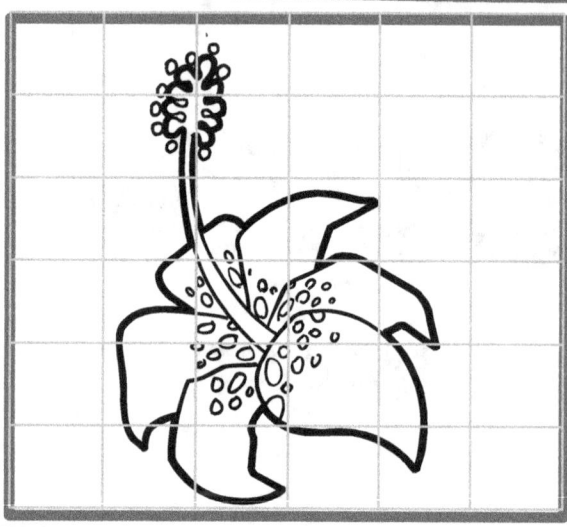

DRAW
THE
IMAGE

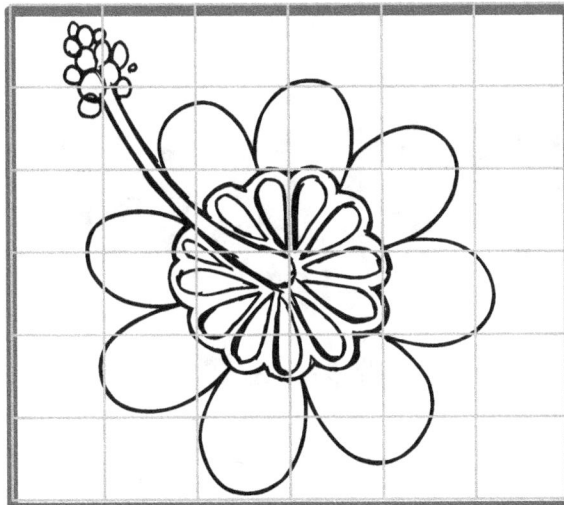

DRAW
THE
IMAGE

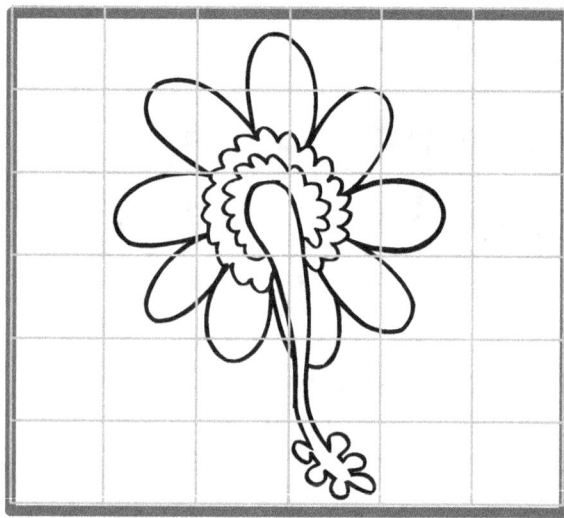

DRAW
THE
IMAGE

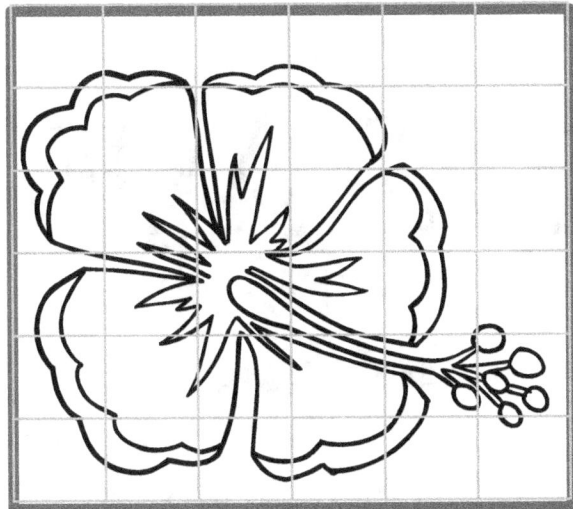

DRAW
THE
IMAGE

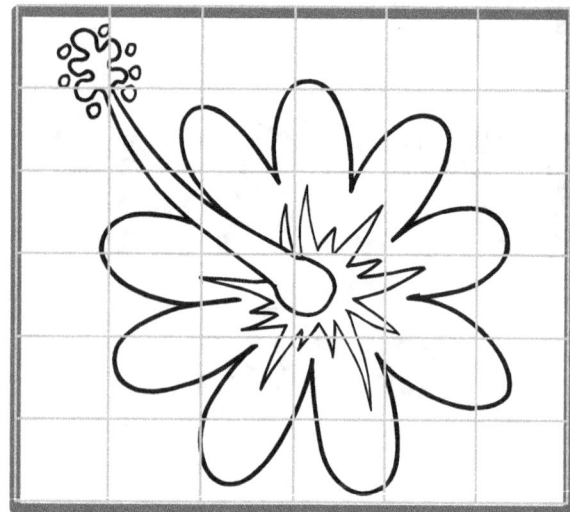

DRAW
THE
IMAGE

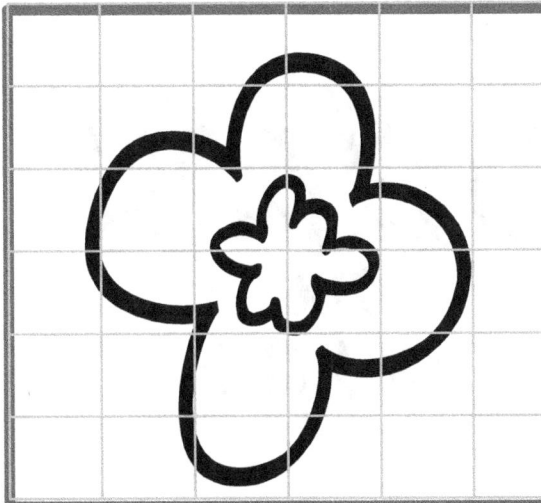

DRAW
THE
IMAGE

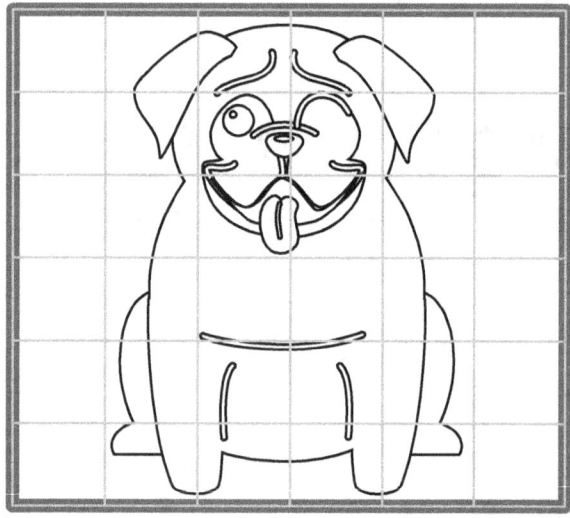

DRAW
THE
IMAGE

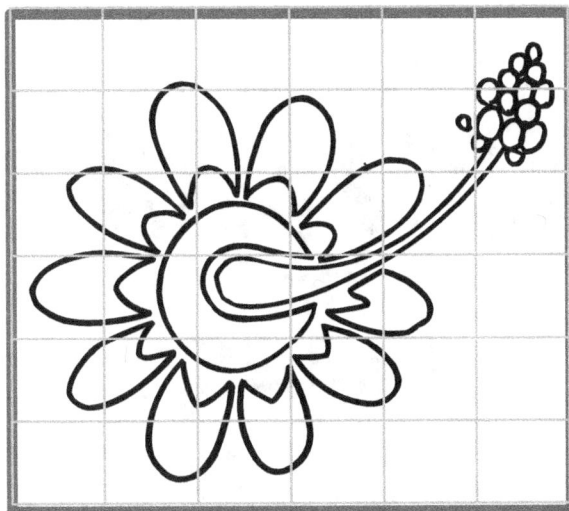

DRAW
THE
IMAGE

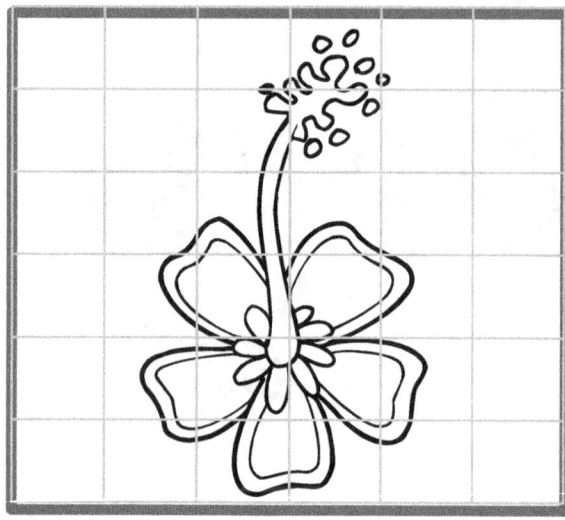

DRAW
THE
IMAGE

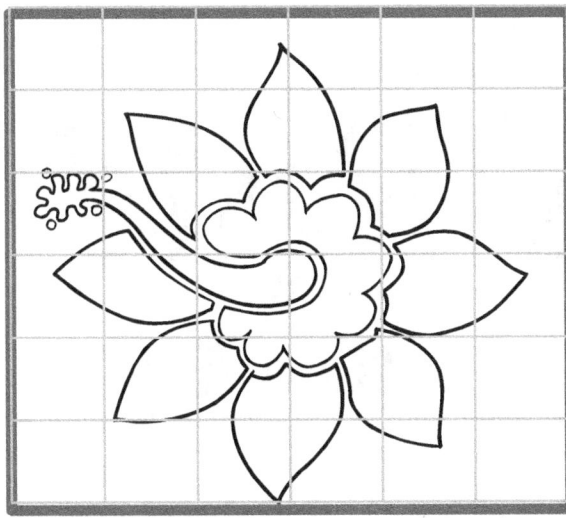

DRAW
THE
IMAGE

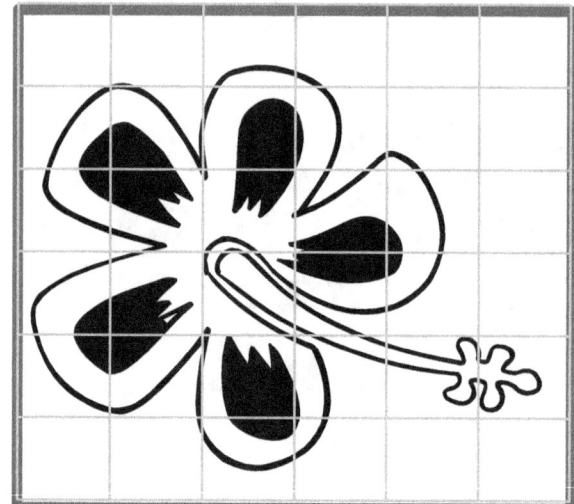

DRAW
THE
IMAGE

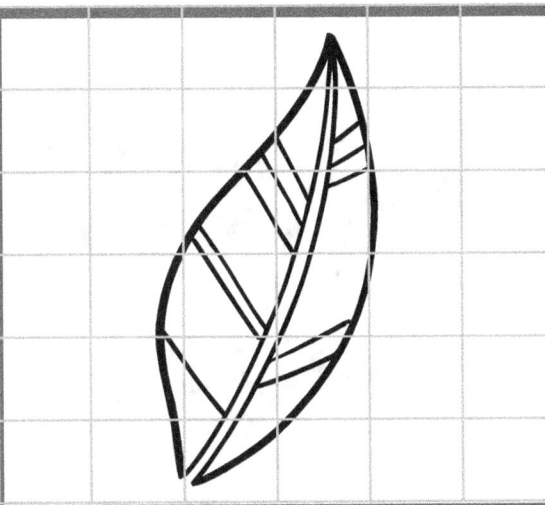

DRAW
THE
IMAGE

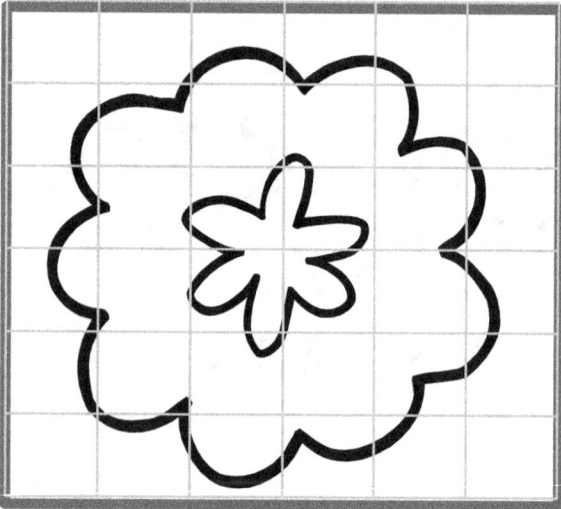

DRAW
THE
IMAGE

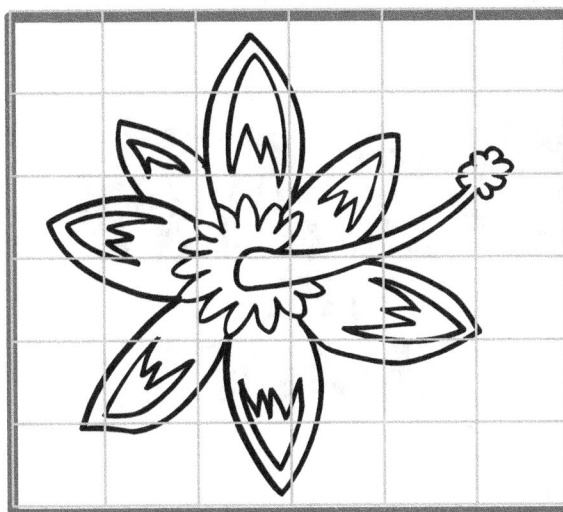

DRAW
THE
IMAGE

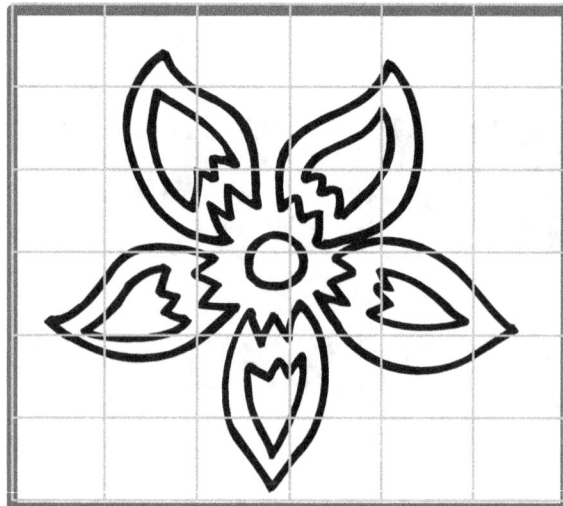

DRAW
THE
IMAGE

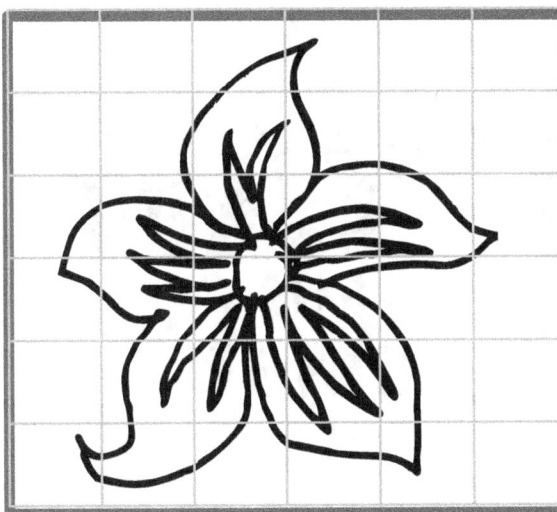

DRAW
THE
IMAGE

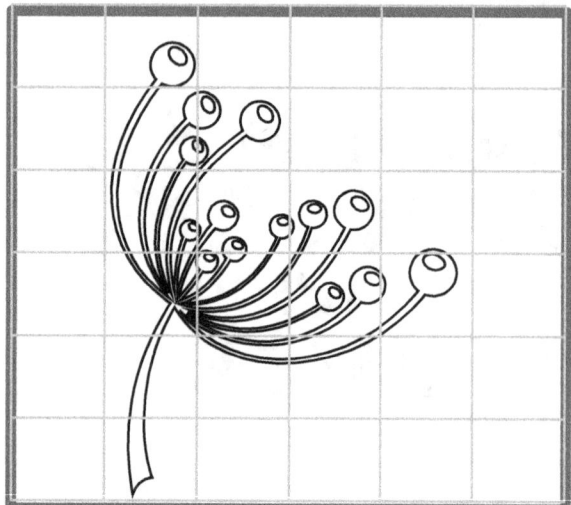

DRAW
THE
IMAGE

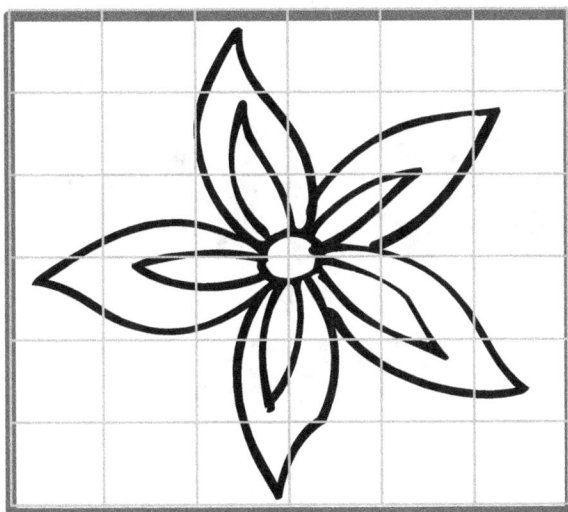

DRAW
THE
IMAGE

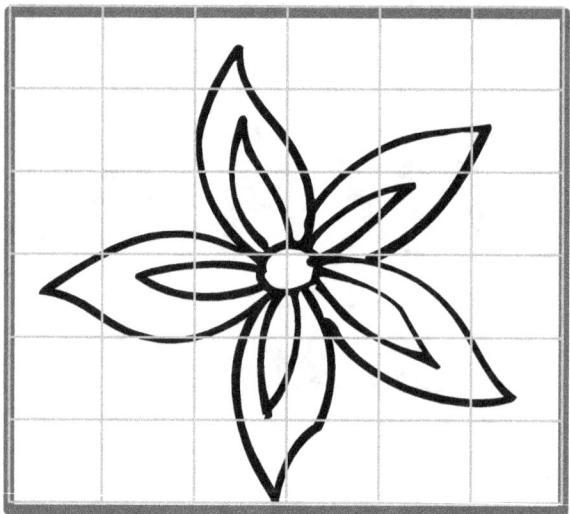

DRAW
THE
IMAGE

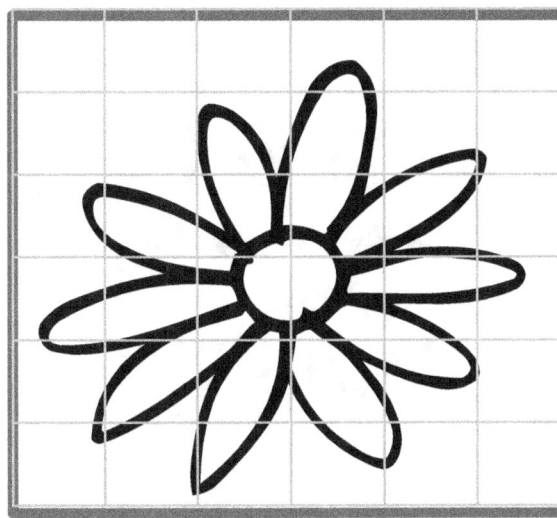

DRAW
THE
IMAGE

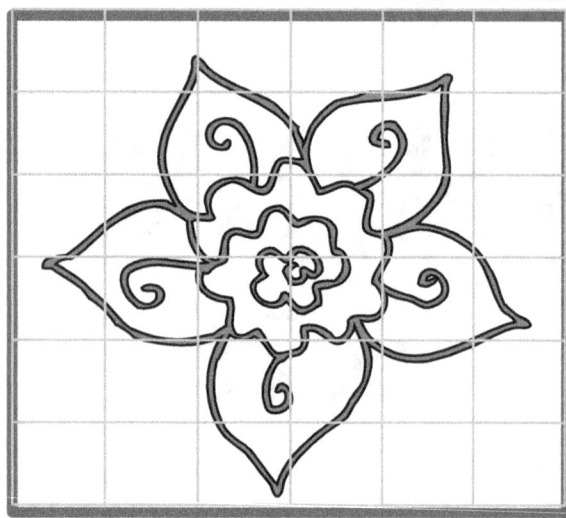

DRAW
THE
IMAGE

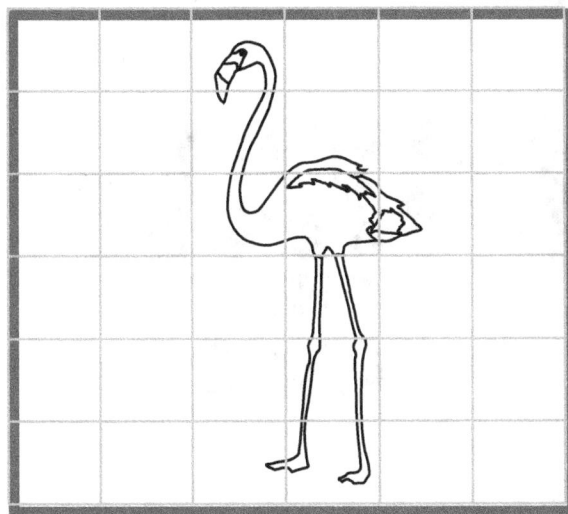

DRAW
THE
IMAGE

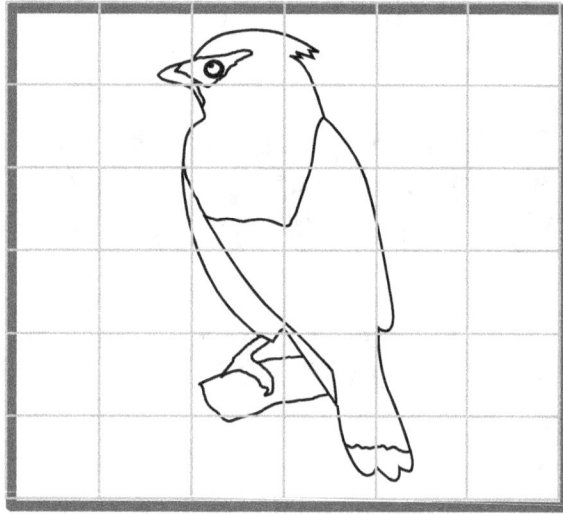

DRAW
THE
IMAGE

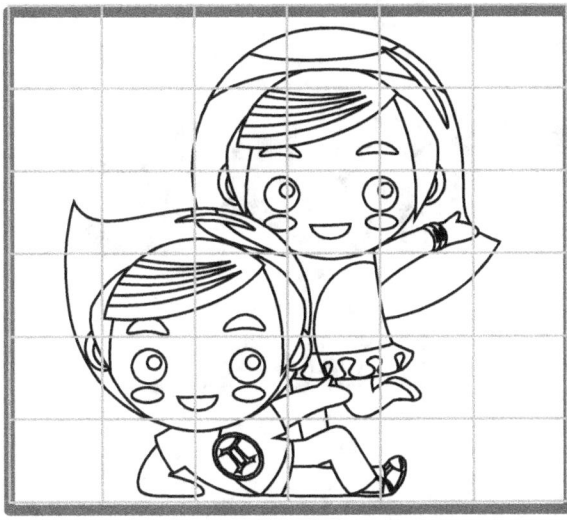

DRAW
THE
IMAGE

DRAW
THE
IMAGE

DRAW
THE
IMAGE

DRAW
THE
IMAGE

DRAW
THE
IMAGE

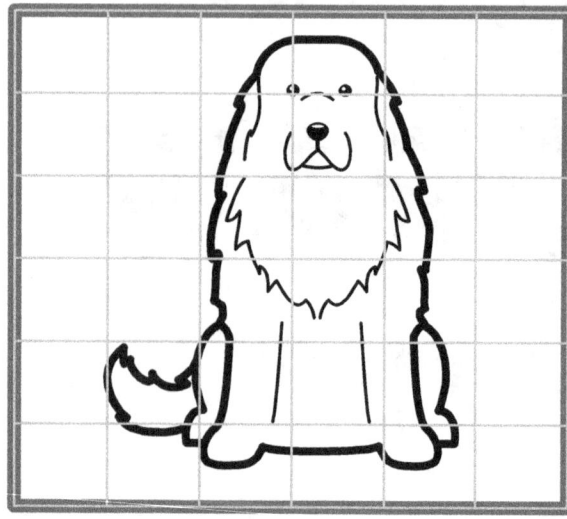

DRAW
THE
IMAGE

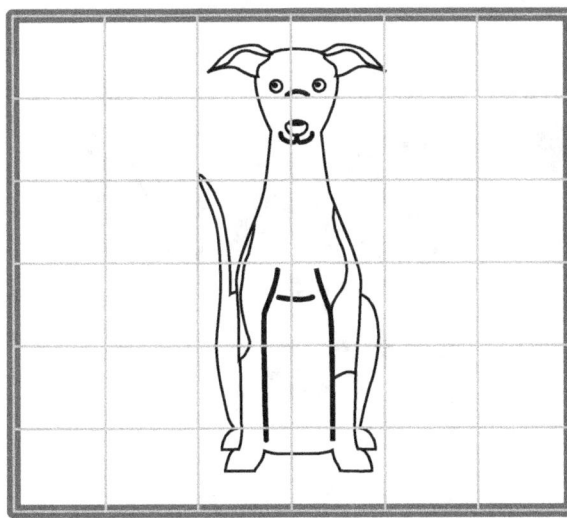

DRAW
THE
IMAGE

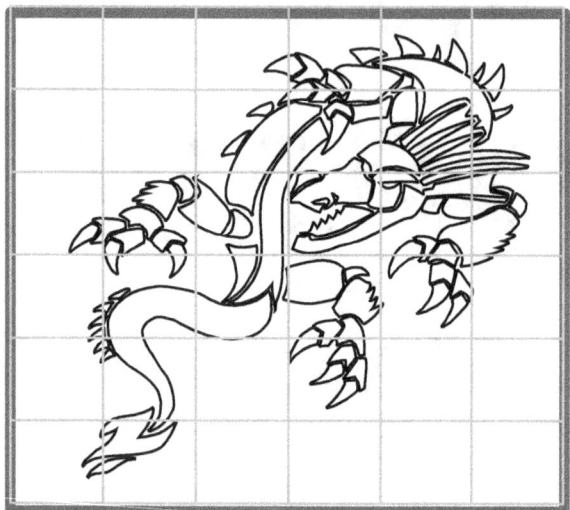

DRAW
THE
IMAGE

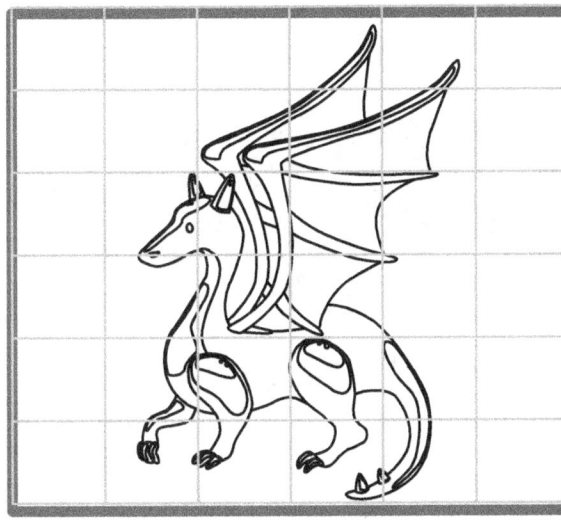

DRAW
THE
IMAGE

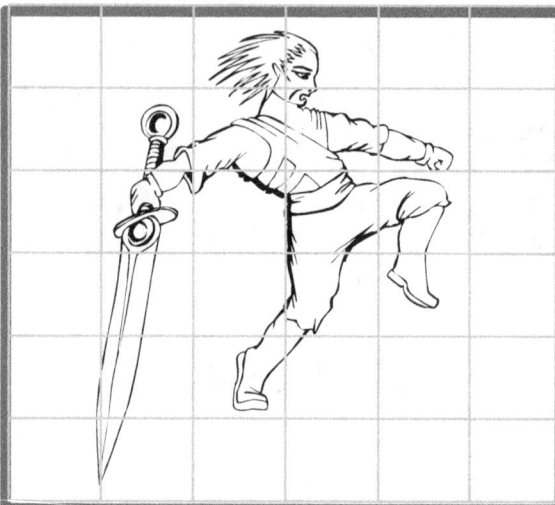

DRAW
THE
IMAGE

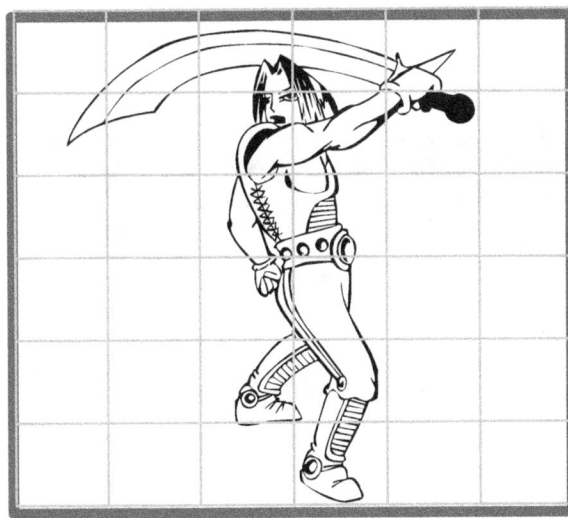

DRAW
THE
IMAGE

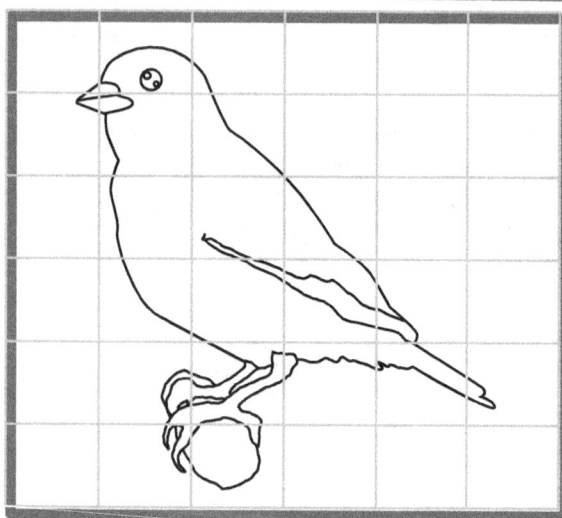

DRAW
THE
IMAGE

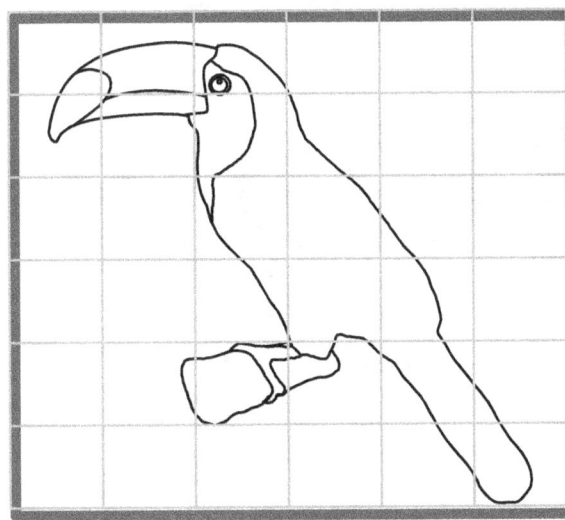

DRAW
THE
IMAGE

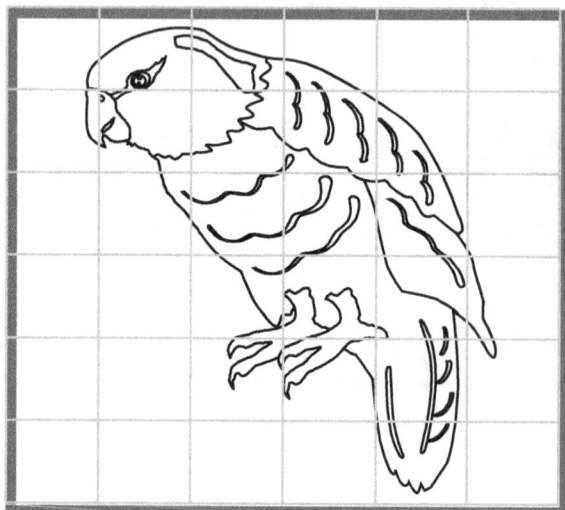

DRAW
THE
IMAGE

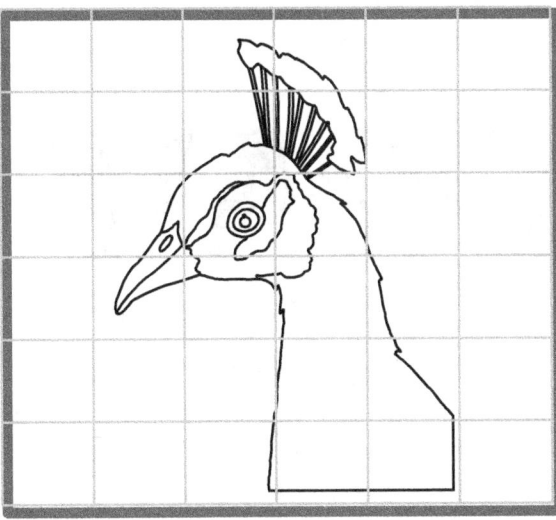

DRAW
THE
IMAGE

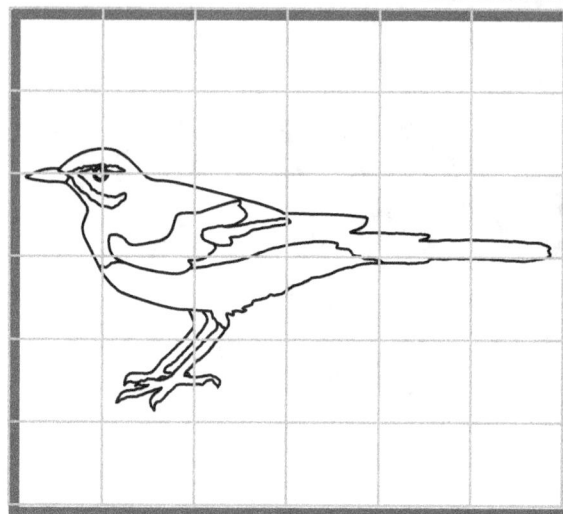

DRAW
THE
IMAGE

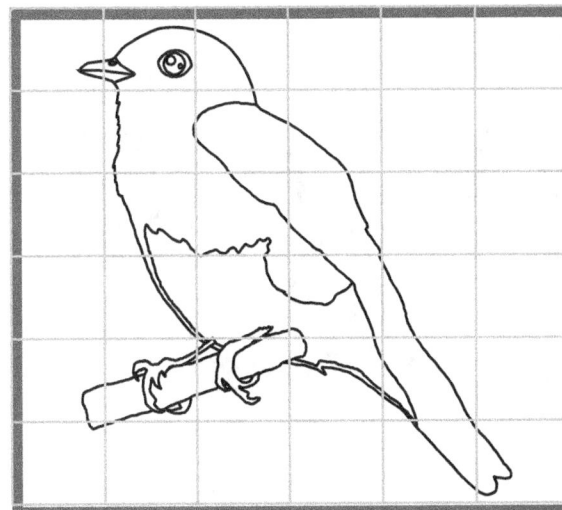

DRAW
THE
IMAGE

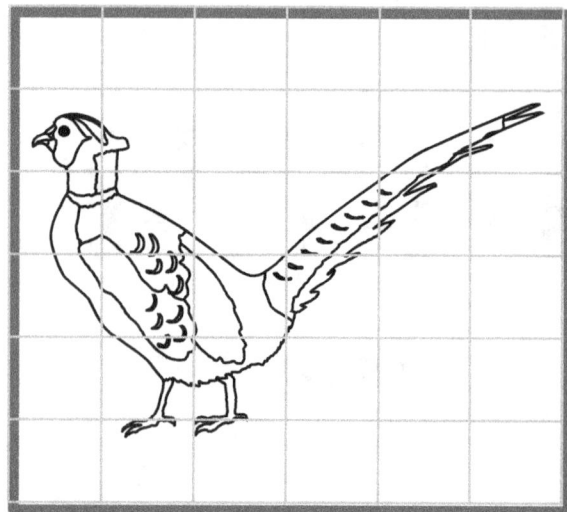

DRAW
THE IMAGE

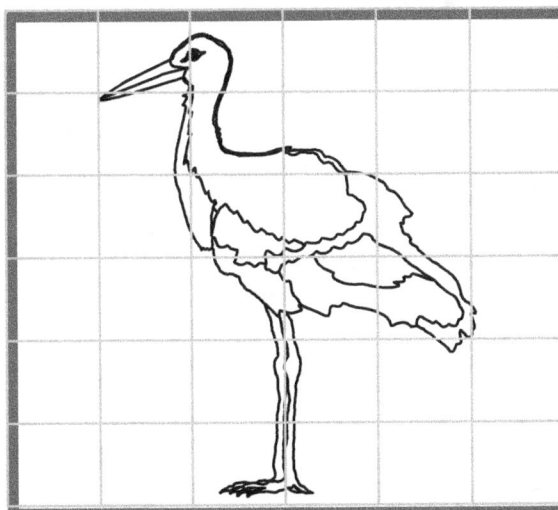

DRAW
THE IMAGE

www.ingramcontent.com/pod-product-compliance
Lightning Source LLC
Chambersburg PA
CBHW082017230526
45466CB00022B/2447